WINDMILLS AND WATERMILLS OF SUFFOLK

JOHN LING

AMBERLEY

First published 2018

Amberley Publishing
The Hill, Stroud, Gloucestershire, GL5 4EP

www.amberley-books.com

Copyright © John Ling, 2018

The right of John Ling to be identified as the Author of this work has been asserted in accordance with the Copyrights, Designs and Patents Act 1988.

ISBN 978 1 4456 6433 0 (print)
ISBN 978 1 4456 6434 7 (ebook)

All rights reserved. No part of this book may be reprinted or reproduced or utilised in any form or by any electronic, mechanical or other means, now known or hereafter invented, including photocopying and recording, or in any information storage or retrieval system, without the permission in writing from the Publishers.

British Library Cataloguing in Publication Data.
A catalogue record for this book is available from the British Library.

Origination by Amberley Publishing.
Printed in Great Britain.

Contents

	Introduction	5
	Key to Map of Main Featured Mills	6
	Map	7
Chapter 1	Windmills: History and Evolution	8
Chapter 2	Post Corn Mills	21
	Holton Post Mill	21
	Saxtead Green Post Mill	24
	Albion Post Mill, Saxmundham	26
	Friston Post Mill	27
	Stanton Post Mill	29
	Syleham Post Mill	31
	Clover's Post Mill, Drinkstone	33
	Webster's Post Mill, Framsden	34
Chapter 3	Tower and Smock Corn Mills	38
	Flixton Road Tower Mill, Bungay	38
	Button's Tower Mill, Thelnetham	40
	Blundeston Tower Mill	42
	Corton Tower Mill	43
	Skoulding's Tower Mill, Kelsale	44
	Fort Green Tower Mill, Aldeburgh	45
	Burgh Tower Mill	46
	Buttrum's Tower Mill, Woodbridge	47
	Tricker's Tower Mill, Woodbridge	49

	Clover's Smock Mill, Drinkstone	50
	Hitchcock's Tower Mill, Rattlesden	51
	Hitchcock's Smock Mill, Rattlesden	52
	Buxhall Tower Mill	53
	Bardwell Tower Mill	54
	Pakenham Tower Mill	55
	Gazeley Tower Mill	57
	Lower Smock Mill, Dalham	58
	Collis Smock Mill, Great Thurlow	59
	Chilton Street Tower Mill, Clare	60
Chapter 4	Windpumps (Drainage Mills)	63
	Herringfleet Mill	63
	Blackshore Mill, Reydon	65
	Old Water Tower Windpump, Southwold	66
	Westwood Marshes Mill, Walberswick	67
	Thorpeness Mill	69
	Eastbridge Windpump, Stowmarket	71
Chapter 5	Watermills: History and Evolution	74
Chapter 6	Suffolk Watermills	80
	Bungay Watermill (River Waveney)	80
	Alton Watermill (River Rat), Stowmarket	83
	Hawks and Bosmere Watermills (River Gipping), Needham Market	84
	Baylham Watermill (River Gipping)	85
	Deben Mills (River Deben), Wickham Market	85
	Woodbridge Tide Mill (River Deben)	86
	Kersey Watermill (River Brett)	87
	East Bergholt: Flatford Watermill (River Stour)	88
	Sudbury Watermill (River Stour)	90
	Euston Watermill	91
	Pakenham Watermill (River Little Ouse, trib. River Blackbourne)	92
	Bibliography	95
	Acknowledgements	96

Introduction

The historic county of Suffolk has a rich milling heritage going back many centuries. Hundreds of windmills and watermills once worked here serving their local communities. Today most have fallen silent and many have disappeared or are derelict, though the modern enthusiast can still see a number of fine examples spread across the county. In recent decades many have been restored by private owners, trusts and councils. Often this transformation stops short of bringing the mill back to full working order but several still operate by wind or water power on at least a part-time basis. Others have had their machinery partly or completely removed and have been converted to residential use. Though these former mills may look very different when compared with their working days, they have thankfully been spared demolition and are still local landmarks.

Windmills and Watermills of Suffolk takes an in-depth look at many of the county's surviving mills. It also acknowledges some of those that have not made it to the present day, particularly the long-lost giants of the past. It traces the rise and fall of traditional windmills and watermills and looks at the reasons behind their decline. This book is intended to inform and entertain those who are already interested in the subject and also introduce new readers to these fascinating relics of old Suffolk.

Information regarding the location of each of the featured mills is included to assist those who wish to visit or view them. It is clearly stated which mills are open to the public but not all of these are accessible all-year round. Information concerning opening times is correct at the time of writing but may be subject to change. In some cases it is necessary to make prior arrangements with the owners and it is advisable to check relevant websites for the latest information. Many mills are on private property and can only be viewed from the roadside. This book is mainly illustrated with new colour photographs specially taken by the author for this publication. Additional images have kindly been supplied by other contributors.

Key to Map of Main Featured Mills

1. Holton Mill
2. Saxtead Green Mill
3. Albion Mill, Saxmundham
4. Friston Mill
5. Stanton Mill
6. Syleham Mill
7. Clover's Post Mill, Drinkstone
8. Webster's Mill, Framsden
9. Flixton Road Mill, Bungay
10. Button's Mill, Thelnetham
11. Blundeston Mill
12. Corton Mill
13. Skoulding's Mill, Kelsale
14. Fort Green Mill, Aldeburgh
15. Burgh Mill
16. Buttrum's Mill, Woodbridge
17. Tricker's Mill, Woodbridge
18. Clover's Smock Mill, Drinkstone
19. Hitchcock's Tower Mill, Rattlesden
20. Hitchcock's Smock Mill, Rattlesden
21. Buxhall Mill
22. Bardwell Mill
23. Pakenham Mill
24. Gazeley Mill
25. Lower Mill, Dalham
26. Collis Mill, Great Thurlow
27. Chilton Street Mill, Clare
28. Herringfleet Mill
29. Blackshore Mill, Reydon
30. Old Water Tower Windpump, Southwold
31. Westwood Marshes Mill, Walberswick
32. Thorpeness Mill
33. Eastbridge Windpump, Stowmarket
34. Bungay Watermill
35. Stowmarket Alton Watermill
36. Hawks Watermill, Needham Market
37. Bosmere Watermill, Needham Market
38. Baylham Watermill
39. Deben Mills, Wickham Market
40. Woodbridge Tide Mill
41. Kersey Watermill
42. Flatford Watermill, East Bergholt
43. Sudbury Watermill
44. Euston Watermill
45. Pakenham Watermill

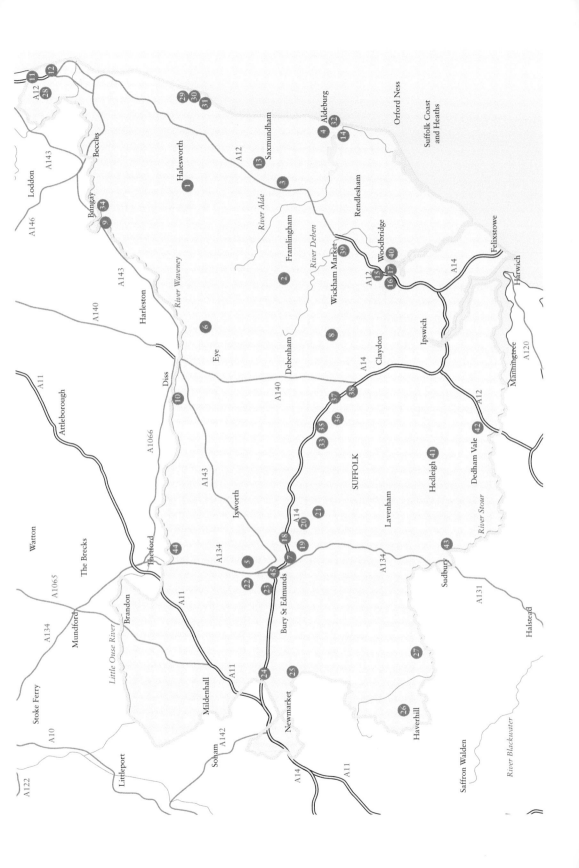

Chapter 1

Windmills: History and Evolution

EARLY HISTORY

There has been much debate over the years concerning the origins of the windmill. By the ninth century, and possibly long before, windmills were in use in Persia (now Iran) for grinding grain and for pumping water. However, these bore little resemblance to later designs and were fitted with up to twelve small horizontal sails.

The first reliable record of a vertical or modern windmill in Europe is not until around 1180, but they may have existed prior to that date. The earliest European windmills were basic open-trestle post mills and Suffolk was one of the first English counties to employ the new technology. Two early post windmills are recorded in Suffolk during the 1190s, one being Dean Herbert's mill at Bury St Edmunds and the other at the lost city of Dunwich. Many more sprang up across the county during the thirteenth and fourteenth centuries, after which their numbers really began to multiply. Later types included the familiar brick tower mill and the smock mill, which had a timber tower above a brick base. Drainage mills or windpumps probably arrived in Suffolk during the late sixteenth century. All of these are explained in greater detail below.

POST MILLS

The post mill remained the most popular type in Suffolk despite later competition from the technically more advanced tower mill. It has been estimated that approximately two thirds of the county's total number of corn windmills were post mills. From tiny, very simple beginnings, the post mill eventually grew into a large and highly sophisticated machine. It was so-called because it was constructed around a central oak post extending from ground level, which supported the main body of the mill. The entire wooden substructure or trestle including the main post, crosstrees and quarter bars was originally left open to the elements, and this remained the norm for several centuries. The wooden body housed the machinery including millstones and revolved on the central post to face the wind. In East Anglia the post mill body is generally known as a 'buck' but this term does not appear to have been widely adopted elsewhere. The front of a post mill is called the breast while the rear is referred to as

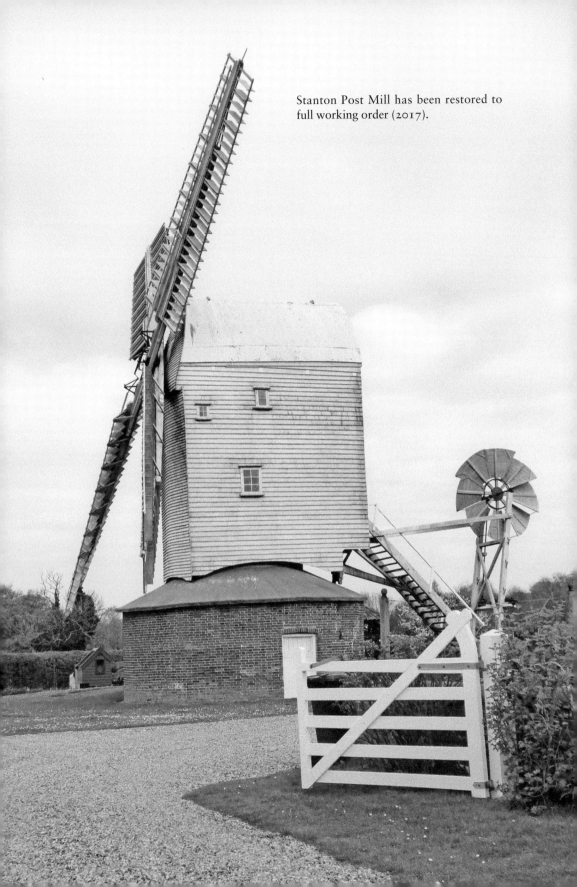

Stanton Post Mill has been restored to full working order (2017).

the tail. If the mill had a fantail it was placed above the tail ladder. Wheels beneath the ladder ran on a 'tramway' encircling the mill.

Suffolk's oldest surviving windmill is Drinkstone Post Mill, which was built around 1689 as an open-trestle type before a roundhouse was added much later. The advent of the roundhouse was an important development in the evolution of the post mill and led to much larger examples being built. Although it usually did not house any machinery, it effectively protected the main post and other vulnerable timbers while also providing valuable weatherproof storage space. Some, however, did contain millstones driven by an auxiliary engine. The roundhouse was usually made of brick, but other materials included stone, flint, wood or clay lump. The latter was used in Suffolk at Syleham and this roundhouse has survived to the present day – unlike the wooden buck that succumbed to the great storm of 1987. As its name implies the roundhouse was generally circular in design, though other shapes were not unknown. Roundhouse roofs were made from a variety of materials including boards and felt, tiles, slates or thatch.

Roundhouses became popular in England from the late eighteenth century onward, first as an addition to existing post mills and later as part of the design and construction of new ones. Several were raised more than once during the working life of a mill, some ending up with three floors instead of the original one or two. Suffolk had some of the tallest post mills ever built with heights of 55 feet (16.76 metres) being claimed for those at Honington and Thorndon, this figure being from the roundhouse base to the top of the buck. The tallest still standing in the county and the whole of Britain is Friston Mill, which is around 51 feet (15.54 metres) in height. Other Suffolk post mills thought to have been at least 50 feet (15.24 metres) tall include those at Blaxhall, Saxmundham, Southwold (the Black Mill), Swilland and Weybread (Drane's Farm). There was a limit to how far a post mill could safely be raised and a few toppled over while being heightened. They were later overtaken by massive brick tower mills, some of which grew to amazing heights.

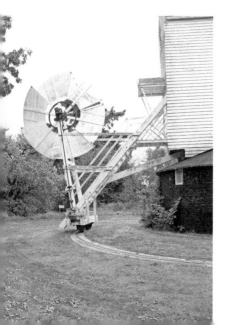

The tail carriage and tramway of Holton Post Mill (2016).

TOWER MILLS

The tower windmill, made from brick or stone, was first recorded in England at Dover Castle in 1295. It is unclear when they first arrived in Suffolk but it may have been during the fifteenth century. One advantage that tower mills had over post mills was that they were topped by revolving caps, meaning that the whole cap assembly including the sails and fantail (if fitted) could be turned according to the wind direction without having to rotate the entire mill body or buck.

Early tower mills were typically small structures just a few stories high, equipped with a conical cap and winded by a tailpole. The canvas on the sails had to be manually set, which meant that the sails needed to come down close to the ground. The invention of the fantail or fly enabled the cap to automatically move to face the wind. Together with the patent sail, which used shutters instead of canvas, this helped revolutionise tower mill development. Towers grew much taller and wider and many had an external walkway known as a reefing stage or simply a stage. This enabled the miller to reach the sails and was accessed by a doorway in the tower.

Eleven storeys is the greatest number definitely attributed to any known windmill, though an unsubstantiated claim of thirteen has been made. Usually only the number of floors in the tower itself is counted, but sometimes the cap is included as the top storey. The height of a tower mill is normally measured from ground level to either the curb (top of the brickwork) or to the top of the cap. Where a finial is attached to the cap it is often included in the quoted height. In some cases the quoted figure is from

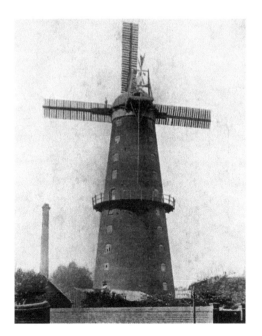
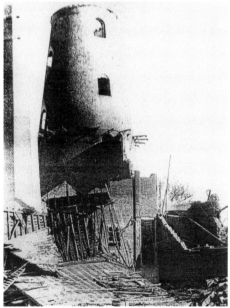

Two lost giants: Southtown High Mill, c. 1900 (left), and the ruins of Green Cap Mill, 1898 (right). (Images supplied by Jonathan Neville)

ground level to the tip of the topmost sail, which can create confusion when comparing the heights of different mills.

Suffolk could once lay claim to two enormous tower mills, which used to stand in the Southtown area of Great Yarmouth. The High Mill and Green Cap Mill are now generally classified as Norfolk mills and both are featured in my book *Windmills of Norfolk* (Amberley Publishing, 2015). However, it should be acknowledged here that for the majority of their working lives, until boundary changes were made in 1891, they were officially in Suffolk.

Southtown High Mill, built in 1812 and demolished in 1905, was 102 feet (31.09 metres) tall to the curb and possibly as much as 122 feet (37.19 metres) to the top of its cap. An iron cage containing a large lantern was attached to the cap and was topped by a wooden weathervane. To the top of this it has been claimed that the total height from ground level was around 135 feet (41.15 metres), though this figure is disputed by some who consider it to be exaggerated. The tower had eleven floors plus the cap and the only mill in England known to have been taller was another eleven-storey giant at Bixley, near Norwich, in Norfolk. The High Mill's external ground-floor diameter was between 40 and 46 feet (12.19–14 metres) and the diameter of its four sails was 84 feet (25.6 metres). In its heyday the mill worked around the clock, but was struck by lightning in 1894 and never worked again. Its demolition was controversial and robbed the town of one of its greatest structures. The photograph reproduced here shows the mill towards the end of its days with a man standing on a sail stock to the left of the cap.

In contrast to the famous High Mill, Green Cap Mill is little known today yet was almost as large. Despite having two storeys less than its neighbour, it was claimed to stand 92 feet (28.04 metres) tall to the curb. Its height including cap must have been well over 100 feet (30.48 metres), which would make it taller than any surviving mill in Britain. Like the High Mill, it was owned by the milling firm Press Brothers. Green Cap Mill was constructed around 1815 but was demolished after being consumed by fire in 1898. The sad remains can be seen in the photograph.

No truly gigantic tower mills survive in Suffolk today, though two converted seven-storey towers can still be seen at Burgh and Kelsale. The tallest to have retained its sails is the six-storey Buttrum's Mill at Woodbridge.

SMOCK MILLS

The smock mill was basically a cheaper form of the tower mill using a timber body on a brick base. Often the base was low but could be up to three storeys high, as was the case with those at Buxhall and Sudbury. This type of mill may have been named due to a perceived resemblance to the traditional countryman's smock. It is not known when the first Suffolk smock mills were built, but the design soon became popular for both corn and drainage mills. During the nineteenth century the smock mill was almost as familiar a sight in the county as the tower mill, though both were heavily outnumbered by the post mill.

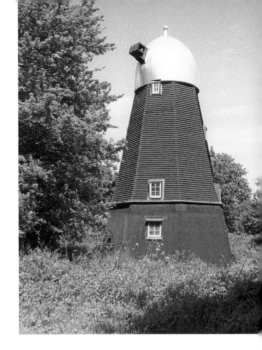

Collis Mill, Great Thurlow, has a three-storey smock body above a single-storey base (2017).

Almost all smock mills built in Suffolk had octagonal bodies or smocks, the known exceptions being those at Wortham and Wangford (both ten-sided) and the twelve-sided smock of Blythburgh Mill. Above the brickwork the smock body was usually clad in horizontal weatherboarding, though vertical boarding was often used in Cambridgeshire. Most Suffolk smock corn mills had fantails but a few had tailpoles. Like the brick tower mill, the smock mill had a rotating cap. Boat-shaped and conical caps were most widespread but other designs were also used. Some taller smock mills had stages around the outside like brick tower mills.

The tallest smock mill still extant in England is the well-known Union Mill at Cranbook in Kent, which is 72 feet (21.95 metres) high to the top of its cap. The six-storey Highfield Smock Mill at Sudbury may have been nearly 70 feet (21.34 metres) tall and was one of the tallest in Suffolk. Wangford Mill was also six storeys tall and a smock mill at Bungay was claimed to have had seven floors, though its height is not recorded. The tallest of the county's few remaining smock mills is probably the four-storey Dalham Lower Mill, which is 50 feet (15.24 metres) high including cap. Suffolk's oldest surviving smock mill at Drinkstone (not to be confused with the post mill mentioned above) was built around 1780 but its base dates from 1689 and was originally a horse mill.

DRAINAGE MILLS/WINDPUMPS

The windpump or drainage mill differs fundamentally from the corn mill in that it does not have millstones. Instead it harnesses the power of the wind to lift water from marshes and other low-lying areas. Water is raised by means of a scoop wheel – consisting of an iron frame with wooden blades and usually housed in an external

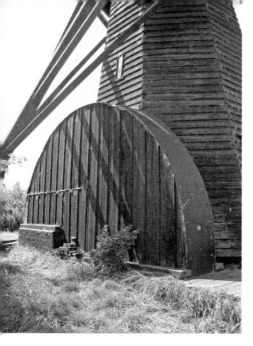

The hoodway (containing a scoop wheel) and braced tailpole of Herringfleet Mill (2016).

structure called a hoodway – connected to the sails by a shaft and smaller wheels inside the mill. In a few cases the scoop wheel was contained within the mill itself. Later drainage mills often used the more efficient Appold turbine pump instead. Westwood Marshes Mill at Walberswick, the shell of which still survives, was an exception to the 'no millstones' rule as it also had a single pair of stones for grinding animal feed. Herringfleet Mill is still in working order with a tailpole and scoop wheel and is located on marshland almost on the border between Suffolk and Norfolk.

Early windpumps were small and primitive machines that originated in the Netherlands. The hollow-post type looked similar to a little open-trestle post corn mill but the central post contained a shaft or rod that (directly or by means of gears) operated the pumping machinery. The skeleton windpump was another fairly basic design usually made of wood and left open to the elements. Smock and brick tower windpumps followed, which to the casual observer looked almost identical to their corn mill cousins. Windpumps were generally smaller than corn mills, an exception being Berney Arms High Mill near Reedham in Norfolk, which stands seven storeys and 70.5 feet (21.49 metres) high and was built to grind cement clinker before being converted to a drainage mill. It had one of the largest known scoop wheels with a diameter of 24 feet (7.32 metres).

SAILS

Windmill sails evolved over the centuries from basic wooden frames with horizontal bars to much more advanced designs. The common sail used canvas spread across the sail and fastened to the sail frame. A Scottish millwright named Andrew Meikle developed the spring sail in 1772, which utilised hinged shutters in lieu of canvas.

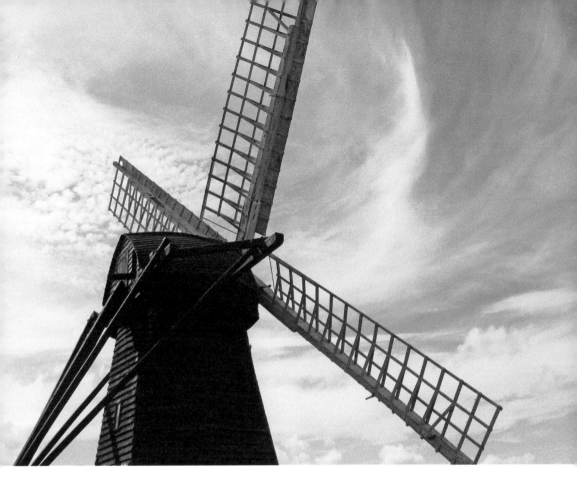

Herringfleet Mill is equipped with cloth-covered common sails (2016).

Captain Stephen Hooper introduced the roller reefing sail in 1789, using small roller blinds in preference to shutters. Norfolk-born engineer William Cubbitt, who was later knighted, patented a new type of sail in 1807. Known simply as the patent sail, it used shutters but combined elements of the spring and roller reefing types in a new design that ironed out many of the problems of both. The shutters could be adjusted without having to stop the mill. Single patent sails had shutters on one side of the sail and double patents had shutters on both sides. Patent sails were installed in many new mills in Suffolk and beyond, and existing ones were often updated to use this cutting-edge technology. In some instances mills worked with sails of more than one type, e.g. one pair common and one pair spring or patent. Some sails were equipped with special longitudinal shutters called air brakes or 'skyscrapers' in addition to the regular ones. Developed by Sudbury millwright Robert Catchpole, their main purpose was to slow down the sails during very windy conditions and several Suffolk mills used them.

The sails of a windmill are attached to large timbers called stocks (also known as middlings in some areas) with two sails (one pair) per stock. The sails and stocks are fixed to the windshaft, a horizontal wooden or (later) cast-iron axle that also carries the brake wheel. Almost all Suffolk mills had four sails, though towards the close of their

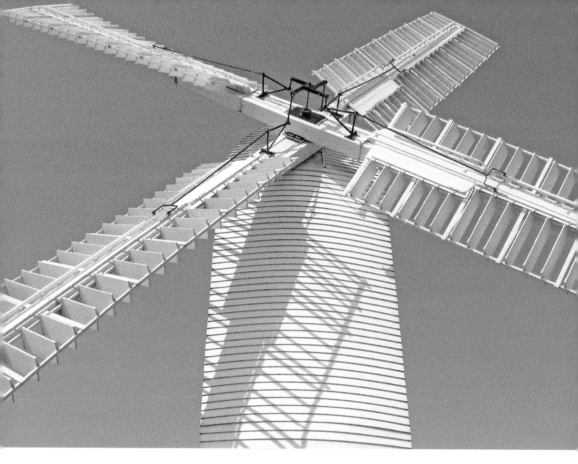

Thorpeness Mill has a new set of patent sails (2016).

working lives some struggled on with just two. Exceptions include a tower mill near Bury St Edmunds, which had six sails and worked until the late 1890s, and a smock mill at Eye also said to have had six sails. There is also a record of a six-sailed mill at Framlingham as early as 1279. The combined diameter or span of a mill's sails varied greatly. The largest claimed for any British mill was a massive 112 feet (34.14 metres) attributed to Bixley Mill near Norwich, part of which still survives on a large private estate.

The largest diameter sails in Suffolk were probably those of Southtown High Mill, Great Yarmouth, before boundary changes sent it over the border to neighbouring Norfolk. They were said to span 84 feet (25.6 metres), though Buxhall Tower Mill was not far behind with a sail diameter of 80 feet (24.38 metres). One or two of the county's largest post mills may have had spans of around 70 feet (21.34 metres). Haverhill Tower Mill was equipped with a very unusual annular (ring-shaped) sail resembling a giant wheel with spokes. It had 120 shutters and measured 50 feet (15.24 metres) in diameter. Boxford Smock Mill was the sole other corn mill in Suffolk known to have had an annular sail. Although it was more common for British windmill sails to turn in an anticlockwise direction (when seen from the front), a number of clockwise-rotating examples were also recorded. In some areas, particularly parts of the south of England, windmill sails are known as 'sweeps'.

TAILPOLES, FANTAILS AND CAPS

Most early mills and some that still survive today were turned into the wind using an external lever known as a tailpole. This extended downwards from the cap of a tower or smock mill or from the buck of a post mill. The miller had to manually turn the buck or cap to avoid the mill being tail winded, which was when the wind suddenly changed direction and hit the back of the sails with such force that the mill could be badly damaged. In severe gales the sails and cap – or even the complete buck of a post mill – could come crashing to the ground.

The fantail (also known locally as the fly or flyer) was a clever device patented by Edmund Lee in 1745. It usually consisted of between six and eight blades or vanes and automatically steered the cap or buck to face the wind. This saved the miller valuable time and effort and most new mills built from the late eighteenth century onwards employed a fantail in lieu of a tailpole. Many older mills were converted, though the tailpole was sometimes left in position. It was, however, still possible for a converted mill to be tail winded as the fantail was unable to react to a wind directly behind it. For this reason a wheel and chain were often fitted to enable the miller to take manual control, though he had to be fit and quick to avoid disaster.

The wooden caps fitted to tower and smock mills came in a variety of shapes and sizes. In Suffolk the most popular designs included a basic round cap, ogee (onion-shaped), domed and boat-shaped. Other styles such as conical, acorn-shaped, 'beehive' or 'pepper-pot' were rarer. Often a finial was placed on top of the cap as a

Pakenham Tower Mill has a dome-shaped cap with a finial, a gallery and petticoat, plus a fantail (2017).

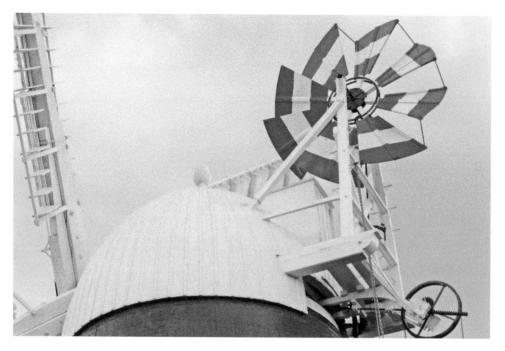

Thelnetham Mill has a 'pepper-pot' cap with a finial and a colourful fantail (2016).

finishing touch, though not on boat-shaped examples. Galleries with wooden or iron handrails were often constructed around caps, particularly boat-shaped ones. This enabled external access to the cap and fan stage, which carried the fantail. Sometimes an extension known as a petticoat was attached to the cap. This covered the brickwork at the top of the tower and helped protect it from the elements. The cap rotated on a circular strip of wood or metal called a curb at the top of the tower. Later tower mills mostly used a 'live' curb with the cap being turned on iron wheels or rollers.

Cap dimensions varied greatly in diameter and height according to the size of the tower. Moulton Mill in Lincolnshire, now recognised as the tallest in England, has a new ogee cap 20 feet (6.1 metres) tall including a 3-feet- (0.91-metres-) high finial. The cap of Southtown High Mill, Great Yarmouth, may have been a similar size, though various conflicting claims have been made. According to the late mills expert and author Rex Wailes (1901–86), the tower mill at Buxhall mentioned earlier had a cap measuring 17.5 feet (5.33 metres) in diameter and 14 feet (4.27 metres) in height. With smaller mills the cap height typically drops to around 10 feet (3.05 metres) or less depending on the design.

MILLSTONES, ROLLER MILLING AND AUXILIARY POWER

Inside a corn mill between one and six pairs of millstones were used to grind grain, animal feed or other items, depending on the size of the mill. While the lower bed stone remained static the upper runner stone turned at around 100–140 rpm. Different types

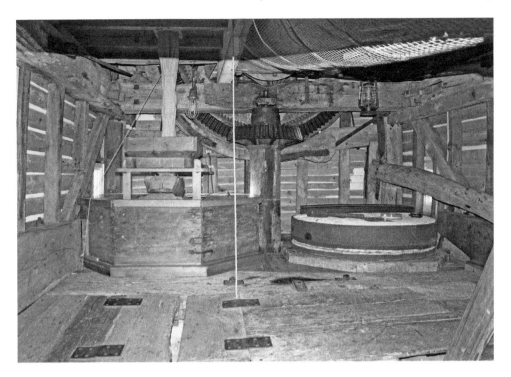

Millstones still in position inside Stanton Mill (2016). (Image supplied by Dominic and Linda Grixti)

of stones included French burr, Peak and Cullin, the former being mainly used for producing flour. Millstones ranged from around 3.5 to 5 feet (1.07 to 1.52 metres) in diameter. They were either driven from above (known as overdrift) or below (underdrift), the latter being the preferred option in the majority of tower mills. Each pair usually had its own governor but sometimes a single governor operated two pairs of stones. Some governors were driven by chains but most windmills in Suffolk used belt drives.

Windmill stones were, of course, traditionally powered by the wind turning the sails, but this was very dependent on weather conditions. A large number of millers used steam and oil engines to provide supplementary power when the wind was light. In some mills the auxiliary engine drove its own separate set of stones while in others the same stones were used when milling by wind or engine power. Often the engine later took over completely from the sails, sometimes extending the mill's working life by several years or even decades.

A landmark development during the nineteenth century was the introduction of the roller mill, which used metal rollers instead of stones and was claimed to produce higher quality flour. The roller plant could be powered by various types of auxiliary engine and many millers installed this newfangled equipment either in the windmill itself or in a separate building nearby, depending on the size of the unit and the amount of space available. Much of the information regarding millstones, roller milling and supplementary power also applies to watermills (*see* chapters 5 and 6).

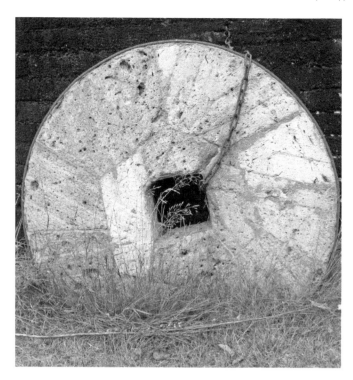

A redundant millstone chained to the exterior wall of Holton Mill (2016).

DECLINE OF THE TRADITIONAL WINDMILL

By the middle of the nineteenth century there were probably at least 450 working windmills in Suffolk, but at the turn of the century their number had halved. Only a hundred or so were still operating by wind power in 1916, though this was partly due to wartime limits on milling imposed by the government. According to Rex Wailes, less than sixty were still grinding corn or other items in the mid-1920s. Between the wars many mills switched over to grinding animal feed. By the time hostilities erupted again in 1939 very few Suffolk windmills were at work.

Several factors including the mass production of flour in vast industrial mills using steam, oil and, ultimately, electric power made the local village or town windmill increasingly uncompetitive. It is ironic that just as the windmill finally reached its peak of technical perfection after many centuries of development, other more modern alternatives combined to ensure its relatively swift decline.

The numbers referred to above are for the traditional corn mills and do not include their cousins the drainage mills or windpumps. These were also very common for many years but their decline largely mirrored that of the corn mills. Few drainage mills continued to work after the Second World War, their jobs having been taken by modern pumps.

Chapter 2

Post Corn Mills

Only a fraction of Suffolk's once plentiful post mills still exist and condition varies considerably from one to another. Stanton Mill, for example, is in full working order but only the ruined or converted roundhouses of some others survive. Between these two extremes, several other post mills are still standing in various states of repair. All those that still retain their wooden bodies or bucks are described below, along with some of the remaining roundhouses.

EAST SUFFOLK (NORTH TO SOUTH)

Holton Post Mill

Location: Mill House, Southwold Road (B1123), Holton, near Halesworth, IP19 8PW. Privately owned and leased to Suffolk County Council. Exterior can be viewed at any reasonable time and the interior is open on some bank holidays. Follow a footpath uphill from the gate of Mill House.

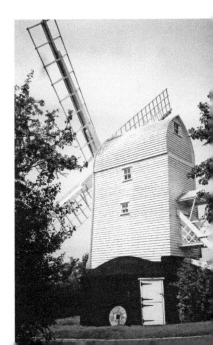

Holton Mill with sails (2005).

My first fleeting glimpses of Holton Post Mill were through car windows on childhood trips to Southwold on the Suffolk coast. It was the mysterious 'mill on the hill', peeping down between trees above the rooftops of picturesque cottages on the road below. Today it still looks down from its lofty perch but, at the time of writing, has lost its sails, though still retains its stocks and fantail.

Built by John Swann, Holton Mill dates from as early as 1749, though the brick roundhouse and fantail are later additions. During its working life the miller had to manually turn the buck (the wooden upper section) into the wind by means of a tailpole. It was originally an open-trestle mill with the centre post exposed to the elements. It is not known when the roundhouse was constructed but it was first recorded in 1835 when the mill was advertised for sale. The roundhouse is unusual in that it has a ground floor and a basement. One disadvantage of a short roundhouse is that the sails pass in front of the doorway, which can make it hazardous to enter or leave while they are turning. At some stage the mill was extended at the head and tail.

William Fiske may have been the mill's first owner and it was auctioned after his death in 1761. It then became the property of the unusually named Brame Oxford until he became bankrupt twenty years later. James Tillot then became the new owner, followed by John Tillot, who died in 1835. Samuel Banell was recorded as miller during the 1810s. After being auctioned again it was acquired by Samuel Wilkinson, who leased the mill to William Taylor. He worked it for a decade until his death in 1845, when Wilkinson's son William took over the lease. The mill changed hands again in 1851 when John Youngs purchased it. After his death ten years later it was sold to Andrew Johnstone of Holton Hall, who then sold it to Thomas Buxton along with the Holton estate. Edward Gotta Youngs, the son of John Youngs, worked the mill on behalf of his father from 1851 and carried on as miller for nearly twenty years despite

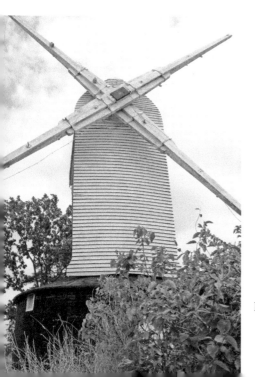

Holton Mill with stocks but no sails (2016).

changes in ownership. He then moved on to Wenhaston Mill and the vacant position at Holton was filled by William Gibson. The mill was yet again offered for sale in 1886 and an engine shed (presumably housing a steam engine) was also recorded at this time. William Gibson stayed at Holton Mill for about forty years until it finally closed in or around 1910.

Most of the internal machinery was taken out when the mill stopped work and for many years it served as an elaborate summerhouse. A viewing gallery and doorway were constructed at the top of the buck at the rear but these have since been removed. A large window above the main doorway of the buck has been replaced by a small one at the very top. A fantail or fly was also added but a larger one replaced it in 1938. With the passing of time the mill's condition steadily declined and it may have become a complete ruin if Colonel T. S. Irwin had not come to its rescue. He bought it in 1947 and the Holton Mill Preservation Fund Committee was formed two years later. Essential repairs were made soon after but it was not until the 1960s that a major restoration was undertaken. The mill was leased to East Suffolk County Council and the work was initially started by volunteers in 1963. They repainted the mill and carried out various repairs. Two of the sails were removed at this time. Beccles millwright Neville Martin undertook extensive repairs in 1966–68, including replacing the roof and some of the internal framing, fitting new sails and stocks, reboarding the buck and much besides. The work was completed in March 1968 but it was realised early on that the structure could not withstand the stress of returning the mill to full working order as originally planned.

Holton Mill has since been kept in a good state of repair and more new sails were fitted in the early 1990s, these being replica or 'dummy' sails as they lacked the shutters of a working mill. It was reported in the summer of 1989 that the previous sails had

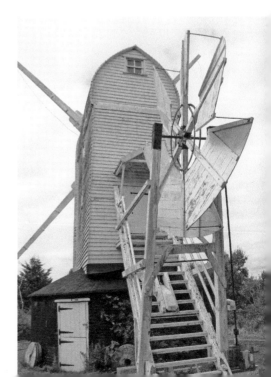

Holton Mill stands high on a hill overlooking the village (2016).

been taken down after just six years. The mill is still privately owned and leased to Suffolk County Council. Visitors are permitted to view the exterior (and the interior on open days) and access is by way of a footpath from the gateway of Mill House. When I finally climbed the hill to encounter Holton Post Mill at close quarters a few decades after first seeing it from a distance, I was far from disappointed. Though not in working order it is one of Suffolk's oldest surviving windmills and is well worth a visit. The sails were still in position in 2011 but on my most recent visit in September 2016 they were absent. The two stocks remained and what was left of the sails could be seen on the ground close to the mill.

Saxtead Green Post Mill

Location: Mill House, Saxtead Green, near Framlingham, Suffolk, IP13 9QQ. Privately owned and run by English Heritage. Open to the public on some days each week between April and September. The exterior can be viewed from the roadside at any time.

One of the finest and best-known post mills in Suffolk, this exquisite example still stands overlooking Saxtead Green as it has done since at least 1796. The present mill was first recorded in that year but is certainly not the first to be built at Saxtead. A windmill existed in the village as long ago as 1287 and it is likely that the present one was constructed on the same site as its predecessors. The mill we see today was originally much lower, the roundhouse having been raised three times. It is now three storeys tall to the eves with three more floors in the buck. It is an impressive sight in a quiet rural setting and attracts many visitors each year.

Saxtead Green Mill had at least ten different millers during its working life, of which Amos Webber was the first. Robert Holmes was in charge in 1810 and a mill house was built for him in that year. Members of the Holmes family worked the mill for several years after that. Later millers included Mr Meadows, Alfred Aldred and Alfred Stephenson Aldred, who was the last of the line. After being tail winded in 1853 the mill was fitted with new sails, a cast-iron windshaft and other new machinery by millwrights Whitmore and Binyon of Wickham Market. The roundhouse was raised to its present height at the same time. More repairs were necessary during the 1870s and 1890s. In its early days the mill probably only had a single pair of millstones but this was later increased to two pairs. Both pairs were controlled by a single governor rather than one governor for each pair as was generally the norm. It was, however, not unique in this respect as at least two other Suffolk mills – at Framsden and Peasenhall – also used this method. Additional millstones in the roundhouse were operated by an engine from the late 1880s until the mill closed. For a number of years until around the 1930s a second much smaller post mill buck could be seen at Saxtead Green near the present mill. This was probably once part of a hollow-post windpump located near Aldeburgh.

After the death of Mr A. S. Aldred in 1947, Saxtead Green Mill stopped work. In 1951 the Ministry of Works took over the care of the mill from Mr S. C. Sullivan, the son-in-law of Mr Aldred. Major restoration followed between 1957 and 1960 and much of the work was undertaken by millwright Jesse Wightman, who also acted as supervisor on the project. He had previously helped Mr Aldred to maintain and repair

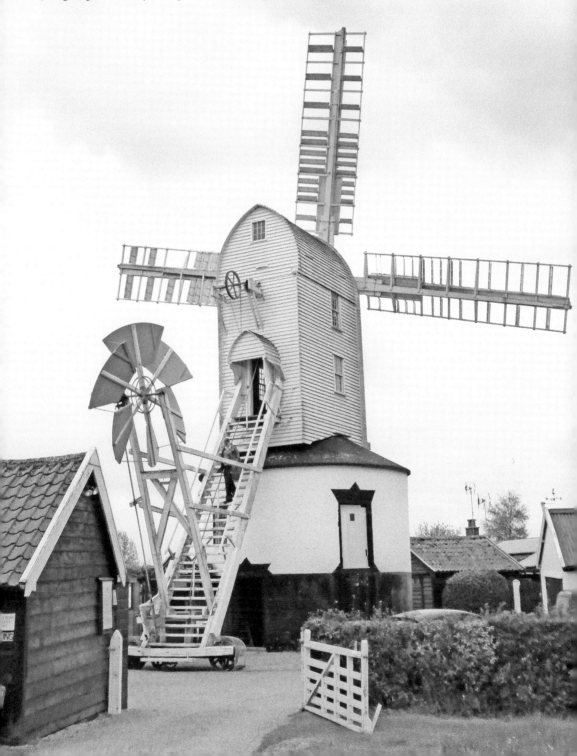

The post mill at Saxtead Green is one of Suffolk's most famous windmills (2017). (Image reproduced by kind permission of English Heritage)

the mill for over thirty years, so was the ideal person to oversee its restoration. The sails were removed and the buck was completely rebuilt. Larger windows were fitted, along with a new wooden brake wheel and other equipment. One sail and a stock were replaced in 1971 and the sails required further attention seven years later.

Saxtead Green Mill has been in the care of English Heritage since 1984, though it is still owned by the Sullivan family. In 2015 the mill was temporarily without its sails while one pair was being repaired and a new pair was under construction. Although it no longer grinds grain, the mill is again in working order with four patent sails and a six-bladed fantail. It is located a number of miles inland but is within the Suffolk coastal district. A model of the mill made around 1898 by A. S. Aldred's uncle is on display in the roundhouse. It depicts an earlier version of the mill when it was an open-trestle type with no roundhouse.

Albion Post Mill, Saxmundham

Location: Rendham Road (B1119), Saxmundham, IP17 1BJ. Privately owned and converted to residential use.

Albion Mill at Saxmundham was undoubtedly one of the tallest post mills ever built in Suffolk and also among the tallest in Britain. It was erected around 1824 and stood over 50 feet (15.24 metres) in height to the top of the buck. The mill's roundhouse contained three floors and was raised at some point during its working life. Albion Mill was probably around the same height as Friston Mill (*see* below) located a few miles to the south. The post mills at Thorndon and Honington in the same county may have been slightly taller but this is disputed by some. After being badly damaged by a lightning strike the sails and buck were taken down in 1907. At this time Albion

The converted roundhouse of Albion Mill, Saxmundham, once one of Suffolk's tallest post mills (2017).

Mill was owned by the Turner family. The roundhouse was then used for a variety of purposes and for several years was part of a filling station on the site. It gained Listed Building status in 1995.

Albion Mill was derelict for several years before being converted to a private two-storey residence in 2007 and a new extension was built adjoining the roundhouse. It has long been surrounded by other properties in the heart of Saxmundham. A faithful model of the mill in its heyday was constructed by John and Derek Goldsmith and this became an exhibit at Saxmundham Museum on its opening in 2004.

Friston Post Mill
Location: Mill Road, Friston, near Saxmundham, IP17 1PH. Privately owned and not open to the public.

Another of the all-time giants of the post mill world can still be found around 5 miles from the Suffolk coast. Friston Mill is the tallest survivor of its ilk in Britain and, like the aforementioned Albion Mill at nearby Saxmundham, one of the largest ever built. According to various sources it stands between 50 feet (15.24 metres) and 53 feet (16.15 metres) in height from ground level to the top of the buck. This makes it taller than some of the county's tower mills and shows how far the post mill had come from its humble and tiny beginnings. The roundhouse was raised to its present height around 1874 and the tail ladder had forty steps. Larger patent sails and a fantail – replacing the original tailpole – were probably fitted around this time.

Friston Mill was built in 1812 on land owned by William and Mary Scarlett, though it was originally located near Woodbridge and transported to its new home by the millwright Collins of Melton. Joseph Collings became owner later that year and several other owners and millers came and went before it became the property of Joshua Reynolds in 1837. Robert, John and Joshua Reynolds worked the mill between then and 1883 when the latter died. It was then handed down to Joshua's nephew Caleb Reynolds Wright before his son, also named Caleb, took over in 1924. He continued milling by wind until 1956, having managed with a single pair of sails since 1943. Work continued for several more years using a diesel engine and an electric motor. The three pairs of millstones were taken out during the 1960s. The mill was earmarked for demolition during that decade but it was then suggested that it should be transported to the Museum of East Anglian Life at Stowmarket, where it would be preserved. After neither of these plans came to fruition it was decided to leave it in situ. Essential repairs were finally carried out in the early 1970s after money had been pledged locally but major restoration had to wait until 1977 when further funds and grants became available. The work, which was undertaken by millwrights Messrs Jameson Marshall, included rebuilding the buck and replacing the roundhouse roof but did not extend as far as replacing the sails. Following the death of Mr Wright in 1972 the mill quickly found a new owner who was committed to its restoration.

Since then the story has been one of continued periodic maintenance and repair, but the goal of bringing the mill back to full working order has to date not been achieved. More major restoration was deemed necessary in the early twenty-first century and a steel 'girdle' was constructed around the mill in 2004. The main post was found to be

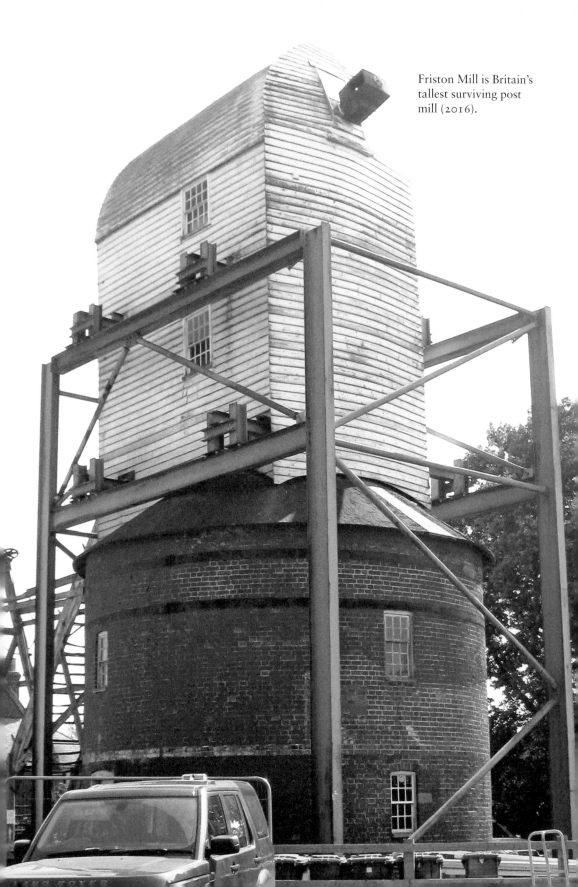

Friston Mill is Britain's tallest surviving post mill (2016).

off-centre and the buck was thought to be in danger of toppling, hence the heavy-duty metalwork. The weatherboarding and other timbers are now urgently in need of repair or replacement. It is hoped that work can start as soon as funds allow, finally securing the future of Friston Mill. According to Historic England it is 'judged to be one of the finest remaining post mills in the world'. Unlike many mills that are located well outside their village, this one stands slightly set back from the roadside in the centre of Friston and is surrounded by houses. Though it is not currently open to the public it is possible to experience its sheer size and tarnished grandeur at close quarters. If Britain's tallest remaining post mill is finally fitted with new sails and restored to working order, it should be quite a sight in this small Suffolk village.

WEST SUFFOLK

Stanton Post Mill

Location: Mill Farm, Upthorpe Road, Stanton, IP31 2AW. Off A143 Bury to Diss Road. Privately owned and not generally open to the public at present.

Another of Suffolk's finest remaining post mills, Stanton Mill has been restored to full working order. It has changed considerably in appearance since being built in 1751 at another site in the village, before being moved to its present home *c.* 1818. Like many others it was originally an open-trestle type before the single-storey brick

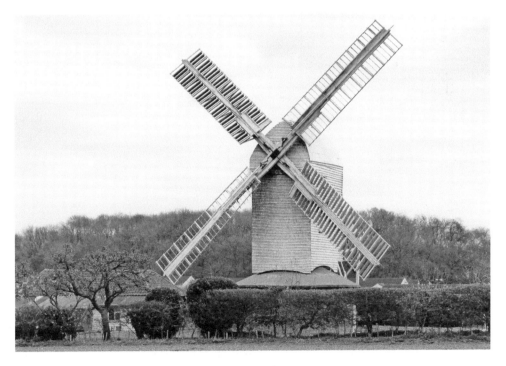

Stanton Mill is one of only a few post mills still working in Britain (2017).

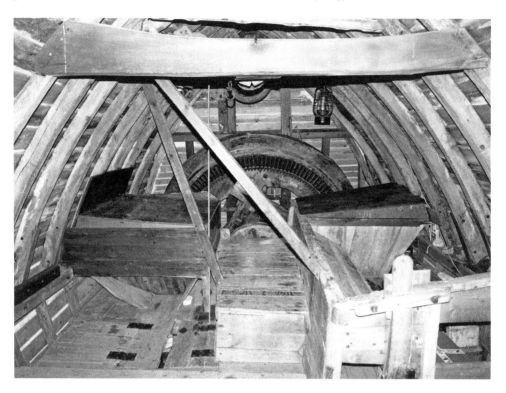

Above and Below: Interior views of Stanton Mill (2016). (Images supplied by Dominic and Linda Grixti)

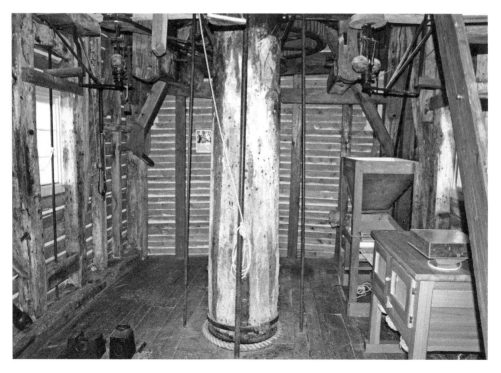

roundhouse was constructed. The mill has an eight-bladed fantail and is now equipped with double patent sails in place of the earlier common type. Two pairs of millstones are still in place in the head of the buck but a pair in the tail was taken out in 1939. The tail of the buck was extended at some point to make room for a wire machine to be fitted.

Stanton Mill stopped work around the end of the First World War and its condition slowly declined. Repairs finally began in 1939 but were interrupted by the start of the Second World War. Nevertheless, it was put back to work during the war years by miller William Bryant with just a single pair of sails but stopped again soon afterwards. The fantail blades were dismantled for safety reasons around 1969 as the mill's condition became increasingly precarious. Urgent repair work was necessary a decade later, but its future remained uncertain before being sold to Richard Duke in 1986.

Under its new owner the mill was restored to working order, but changed hands again in 1993. It was purchased by well-known mills enthusiast and author Peter Dolman, who for many years was secretary of Suffolk Mills Group. Much additional work was undertaken during his period of ownership before his untimely death in July 2002. The mill's present owners Dominic and Linda Grixti took charge in 2004. Today the mill still works by wind power and flour, oats and other items are available for sale on the premises. The mill itself is currently open by prior appointment only.

The converted roundhouse of Stanton Chair (also known as George Hill) Mill still exists in the village. Built in 1824 and dismantled during the First World War, it was claimed to be 48 feet (14.63 metres) tall to the top of the buck. Another post mill stood in Bury Road, Stanton, from the 1820s until at least the 1880s. Other mills in and around the village included Lower Mill, which was moved to an unspecified location in 1818, and a smock mill dismantled around the outbreak of the Second World War, which had been in existence since at least 1764. Going back much further in time, a windmill was first recorded at Stanton as early as the 1390s.

NORTH AND MID-SUFFOLK

Syleham Post Mill

Location: Windmill Lane, off Wingfield Road, Syleham, IP21 4LU; approx 3.5 miles south-west of Harleston and 6 miles north-east of Eye. Roundhouse privately owned and not open to the public.

The village of Syleham once had two working mills, one powered by wind and the other by water. The watermill, possibly built in the late eighteenth century, burned down in May 1928. The windmill also suffered a cruel and violent fate nearly sixty years later, when it became a victim of the great storm of 1987. All of the upper part of the mill was lost but the roundhouse survived.

In 1823 Syleham Windmill made the 2-mile journey from Wingfield Green, where it had stood since 1730. It was acquired along with another mill at the same location by Robert Sparkes, who decided to move one to the Great Green at Syleham. A new two-storey roundhouse was constructed from clay lump rather than brick and the rest

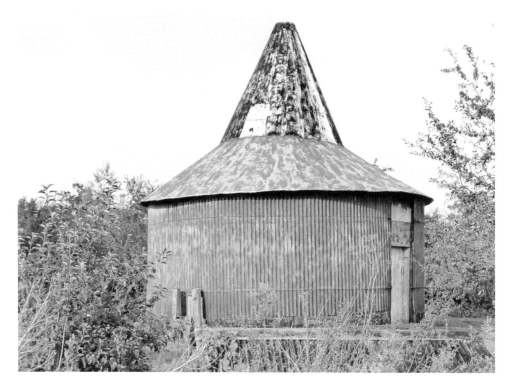

Only the unusual roundhouse of Syleham Mill still survives (2017).

of the mill was rebuilt above it. The mill was equipped with one pair of common sails and one pair of spring sails, which drove two pairs of French stones. By the late 1830s George Dye had become miller, and upon his death in 1847 the mill was bought by John Bokenham. He sold it a year later to John Bryant, who worked it in conjunction with the remaining post mill at Wingfield until his death in 1867. It was then inherited by his widow Sarah and remained in the same family until shortly after the death of Arthur Bryant (John Bryant's grandson). In 1945 the mill was purchased by Jack Penton, who sold it four years later to Elizabeth Jillard. The sails stopped turning in 1951, by which time only one pair remained after the mill was tail winded in 1947. One pair of stones was moved to the roundhouse and Miss Jillard continued her business until 1967 using a Ruston & Hornsby oil engine purchased by Arthur Bryant in 1932.

After the mill was sold to Arthur Bryant's grandson Ivor Wingfield, repairs were made to the roundhouse in the mid-1970s and further work was planned on the buck, sails and fantail. Hopes of fully restoring Syleham Windmill were finally scuppered on 16 October 1987 when the wooden buck was destroyed during the 'hurricane' forever associated with unfortunate television weatherman Michael Foot. The exterior of the roundhouse is now clad in corrugated iron as a defence against the elements, while a distinctive 'witch's hat'-style conical roof rises above it. The remains of the mill stand on private land at the end of a single-track lane and can also be seen from a public footpath across a neighbouring field.

Clover's Post Mill, Drinkstone

Location: Woolpit Road, Drinkstone, near Bury St Edmunds, Suffolk, IP30 9SP. Privately owned and open to the public by prior appointment only.

Drinkstone Post Mill is Suffolk's oldest surviving windmill and is one of a pair of mills worked by many generations of the Clover family. The other, a smock mill, is located a short distance away and dates from the late eighteenth century, but is built on the base of an earlier horse-powered mill. The post mill is thought to have been built in 1689, as that date is recorded inside the mill. This makes it one of Britain's oldest extant windmills, though Bourn Mill in Cambridgeshire (built before 1636 and possibly much earlier) and Outwood Mill in Surrey (erected in 1665 and still in working order) both predate it. It has been claimed, however, that some of Drinkstone Post Mill's timbers including its main post date back to the sixteenth century.

The Clover family's ownership of the post mill lasted from around 1775 until 1997. Samuel Clover Sr gifted it, together with the horse mill and the mill house, to his son Samuel Jr in 1775. The properties were later inherited by other family members including John, Daniel and Wilfred. The buck, which is mainly made from oak, was originally much smaller than it is today. It is thought that at some point in its long history the buck was reversed, with the sails being refitted to what was originally the tail. The single-storey roundhouse, built from stone and brick, was added around 1830

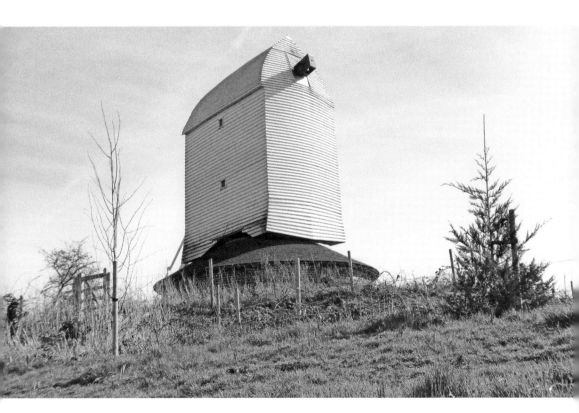

Clover's Post Mill in Drinkstone is the oldest windmill still standing in Suffolk (2017).

but for the first 140 years of its life the mill was the traditional open-trestle type. It worked with two common and two spring sails and it was not until the 1940s that it acquired a second-hand fantail in place of the tailpole that had sufficed since its inception. The fantail and sails were seriously damaged during a storm in 1949, after which the mill stood idle before being restored to working order in 1962 by its owner Wilfred Clover. He inherited the post and smock mills following the death of his father Daniel, who had worked them since around 1900. Milling continued after the damage to the post mill using an oil engine at the smock mill.

Following its restoration, the post mill continued to grind animal feed using two pairs of stones, but the business was scaled down. A replacement fantail was salvaged from the derelict mill at Woolpit and fitted in 1963. Drinkstone Post Mill was still working with four sails in 1970 when it made an appearance in the 'Don't Forget the Diver' episode of the highly successful BBC comedy series *Dad's Army*. It remained in working order for a number of years following its spot of television stardom, though the sails turned less often in later years. The mill was purchased by new owners in 1997 and was by then in need of further restoration. It was pictured with a single pair of sails in 2002 but these were removed due to rot. A major programme of repairs was planned and funds were made available from a variety of sources. Work began in the spring of 2005 but was put on hold when the new owners moved out of the mill house. It is hoped that at some stage the post mill can still be returned to its former glory. The smock mill's history is detailed in chapter 3.

Webster's Post Mill, Framsden

Location: Old Mill House, Mill Hill, Framsden, IP14 6HB (on the B1077 approx. 9 miles north of Ipswich). Privately owned and open to the public by prior appointment only.

Webster's Mill at Framsden is surpassed in height by just one other surviving Suffolk post mill and is possibly the second tallest left in Britain. Standing 48 feet (14.63 metres) tall to the ridge of the buck, it is only a few feet shorter than Friston Mill near Saxmundham. The mill dates back to 1760 but was originally a much shorter and less sophisticated structure without a roundhouse or fantail. John Flick was its first owner and the mill stayed in the same family until 1836. After being bought by Essex brickmaker John Smith, Framsden Mill was brought up-to-date with the addition of a two-storey brick roundhouse and a fantail instead of the original tailpole. A new tail ladder with thirty-three steps was necessary due to the increased height. New patent sails measuring 64 feet (19.51 metres) in diameter replaced the old common type and a cast-iron windshaft was fitted in lieu of the wooden one. Also at this time two pairs of stones were installed in the head of the mill in place of the single pair previously fitted, while a pair located in the tail was removed. The mill was slightly extended at the rear to make room for new equipment and some of the internal woodwork was reinforced. The work was carried out by John Whitmore & Sons.

John Smith sold his much modified and improved post mill to William Bond in 1843. He owned it for nearly thirty years before Joseph Rivers bought it in 1872. The mill became the property of Edmund Webster in 1879, then stayed in the same family

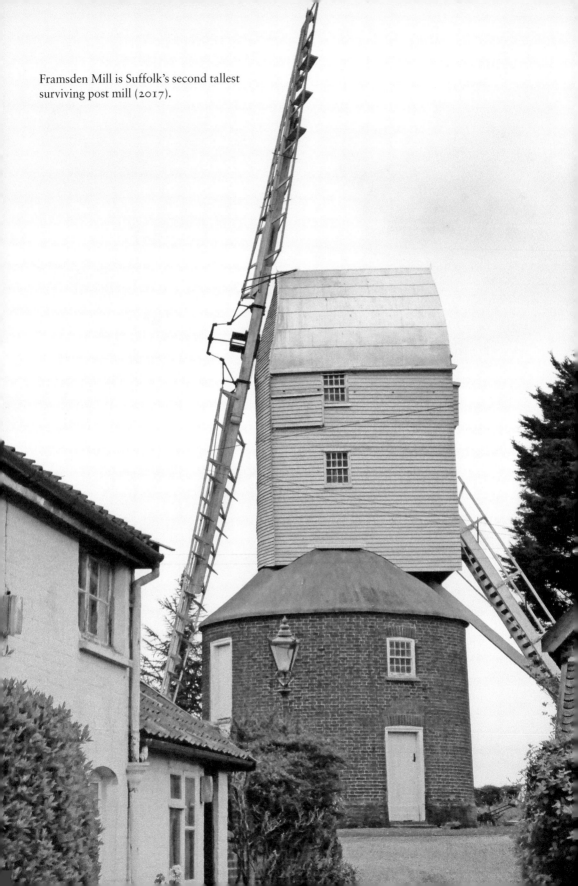

Framsden Mill is Suffolk's second tallest surviving post mill (2017).

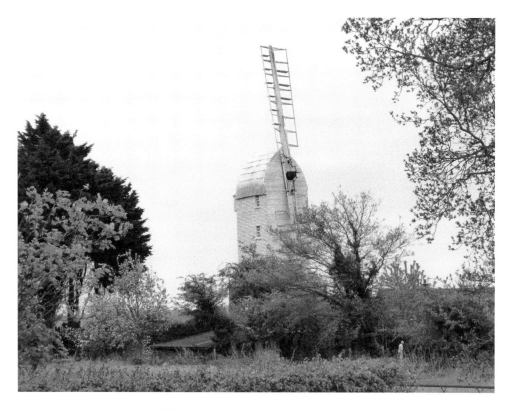

For many years Framsden Mill has carried a single pair of sails (2017).

for the rest of its working life and became known as Webster's Mill. Edmund Samuel Webster later took over the reins from his father and was the last miller at Framsden when the mill closed around 1936.

After becoming derelict the mill was restored between 1966 and 1973 by a number of volunteers including Chris Hullcoop, Vincent Pargeter, Peter Stenning, Stanley Freese, Frank Farrow and a young Adrian Colman, who later restored his own post mill at Garboldisham in Norfolk, which he still runs. Author Brian Flint also contributed to the restoration of Webster's Mill and later wrote a very detailed account in his *Suffolk Windmills* (1979). Briefly, the work included the removal of one pair of damaged sails and a stock, repairing the remaining sails and stock, the fitting of new weatherboarding, repairs to the central post, roundhouse roof and rear steps, plus numerous other jobs. It was decided to leave the mill with just two sails to help alleviate the strain on the buck. The remaining sails finally turned again in May 1972 and a little wheat was ground, but it appears that the sails have rarely turned in recent years.

Webster's Mill was first opened to the public by its owner Stanley Ablett in the late 1960s. He built up a museum of bygones and his son John, who still owns the mill, has extended the collection. Another post mill once existed in Framsden at Ashfield Place from the 1880s until around the end of the First World War.

OTHER POST MILL REMAINS

The complete and recently restored post mill at Thorpeness was converted from a corn mill to a hollow-post windpump after it was moved from nearby Aldringham. Its unusual history is recorded in chapter 4.

The wooden buck of Creeting St Mary Mill (without its post or trestle) was used for many years as a dovecote and is now a highly unusual shop. It was moved to what is now Alder Carr Farm (IP6 8LX) after the mill – which was built in 1796 and situated around half a mile from its present location – was dismantled around 1860.

In addition to those already mentioned, quite a number of post mill roundhouses still survive minus their wooden upper body or buck. Many have been converted to houses or have been incorporated into larger dwellings. Others are used for storage or are derelict. Many are still recognisable as mill roundhouses while others have been much altered and extended and bear little resemblance to their former selves. Some of the most interesting examples are described briefly below.

Honington Mill (IP31) was claimed to be 55 feet (16.76 metres) tall to the roof of its buck and was one of Suffolk's tallest post mills. After the mill was dismantled the three-storey roundhouse was converted to residential use.

Thorndon Mill near Eye was also said to be 55 feet (16.76 metres) tall. It was built in 1797 and the buck was taken down in 1924. The three-storey roundhouse was used as a store for many years but has now been converted to a house. It is located on Mill Lane, The Street, Thorndon, IP23 7JP.

Swilland Mill, built in the early 1800s and dismantled in the mid-1950s, was another tall post mill. It stood 25 feet (7.62 metres) tall to the top of the roundhouse and 51 feet (15.54 metres) to the roof of the buck. The roundhouse was restored in the early 1970s from a derelict state by a potter who then used it to show his wares. It has now been converted to private accommodation as part of the Swilland Mill complex (including the former steam mill building) on Swilland Road, IP6 9LW.

The roundhouse of Peasenhall Mill still survives off Mill Road, Peasenhall, IP17 2LJ. The mill was built in the early 1800s and was dismantled in the late 1950s. A conserved smock mill body can also be seen on the same site (*see* photograph in chapter 3).

After Hudson's Mill at Snape was dismantled in 1933, its roundhouse was modified and converted to residential use by classical composer Benjamin Britten. It still stands on Church Street, Snape, IP17 1SX.

Chapter 3

Tower and Smock Corn Mills

Although Suffolk tower mills were built in smaller numbers than post mills, more have survived to the present day due to their more solid all-brick construction. The condition of individual mills ranges from working order to derelict. Others have been truncated or have modern extensions attached and have become full- or part-time homes. Most of those that still have substantial remains are featured below.

Only a handful of smock corn mills have survived in Suffolk and none have retained their sails. The basic design was flawed in that the wooden smock body or tower was not completely watertight. Rot could set in after a relatively short period of time and the weatherboarding often had to be repaired or replaced several times during a mill's working life. As a result they are now much less plentiful than their brick tower cousins.

NORTH SUFFOLK

Flixton Road Tower Mill, Bungay

Location: Tower Mill Road, off Flixton Road, Bungay, NR35 1RJ. Privately owned and converted to residential use.

The historic market town of Bungay in north Suffolk is situated in the Waveney Valley 5.5 miles west of Beccles and just south of the border with Norfolk. Its most famous landmarks include the extensive ruins of Bigod's Castle, the Butter Cross dating from 1689 and the imposing Church of St Mary. The church will always be associated with the legendary Black Dog of Bungay, a giant supernatural hound that is said to have killed worshippers there during a thunderstorm on 4 August 1577. The apparition has been reported in and around the town on several other occasions over the intervening centuries up to the present day.

Less well known is the fact that Bungay once had no fewer than eight windmills, though they did not all work simultaneously. Now just the truncated and converted tower of one still exists. Flixton Road Mill was built in 1830 and was a typical six-storey corn mill. It was equipped with a fantail and four patent sails, which drove three pairs of stones. The mill continued to operate during the First World War and worked for a total of eighty-eight years, before a lightning strike in 1918 sent the sails crashing to the ground. The damage was estimated at around £1,500 but the sails

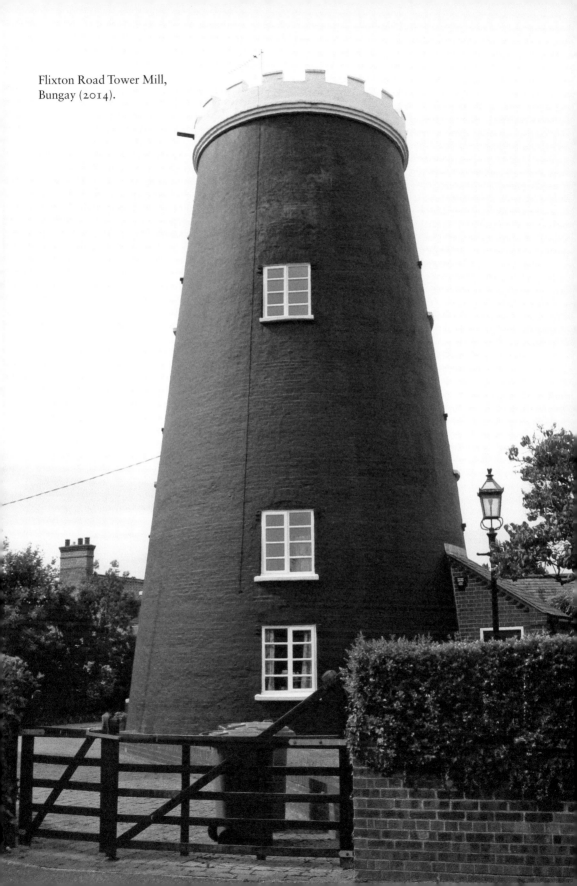

Flixton Road Tower Mill, Bungay (2014).

were never refitted. The miller carried on working for a few months using a gas engine before deciding to close the premises. After that it remained empty before a new owner bought the mill in 1924 and converted it to a private residence. The top floor and cap were removed and a castellated edge was added at the top of the truncated tower. A new flat roof was fitted, accessible by steps within the tower, which enabled the owner to admire the views in every direction. The second floor reefing stage was taken down and a large extension was later added at ground level. My father, who was born and bred in Bungay and was a boy at the time, recalled the old mill being turned into a house. It is unrecognisable as the working mill shown in old photographs.

Part of the building was damaged during the great storm of 1987 and had to be rebuilt. Today it stands as part of a housing estate off Flixton Road on the outskirts of Bungay. It is not a great distance from the town centre but is still privately owned and not accessible to the public. The Grade II-listed four-bedroom property was advertised for sale in 2015 after being owned by the same family for twenty-seven years. It has been extensively renovated and improved over the years since its original conversion.

Two other windmills also stood on Flixton Road. One, a smock mill, is said to have been destroyed during a gale in 1864. The other, a post type, was constructed around 1826 and demolished in 1879. Upland Post Mill was situated on Hillside Road, Bungay, from around 1838 until 1918. Wren's Park Mill was either a post or smock mill and was first recorded in 1775. It was still standing in 1824 but little is known after that date. Sayer's Tower Mill was built c. 1826 but was consumed by fire in 1868. Bungay's other 'lost' windmills include a mill of unspecified type recorded in 1764 and another– possibly a smock type – that existed from the 1780s to around 1830.

The town also once had working watermills, and the extensive converted remains of Marston's Mill can still be seen in Staithe Road, NR35 1EU (*see* chapter 6).

Button's Tower Mill, Thelnetham

Location: Mill Road, Thelnetham, near Diss, IP22 1JS. Run by Suffolk Building Preservation Trust. The exterior can be viewed at any time and the interior on open days.

Button's Mill at Thelnetham is located just inside Suffolk close to its boundary with Norfolk and dates from 1819. An earlier mill is known to have existed nearby or perhaps on the same site during the 1780s. The present one was built by millwright George Bloomfield and was originally equipped with four common sails and a wooden windshaft. These were replaced with patent sails and a cast-iron windshaft in 1832. A fantail was also added that year. William Button was the first owner and miller until his death in 1837 and it stayed in the Button family for another twenty-five years. William's wife Rebecca took over the running of the mill together with the couple's son Richard, who continued as miller until 1860. His sons Richard and William then became joint owner-millers before selling the mill in 1862 to Richard Peverett. Later millers included his son Stephen Peverett (1862–79), Henry Bryant (1879–1920) and Alphonso and George Vincent (1920–24). A steam engine supplied supplementary power from 1892 before being superseded by an oil engine in 1914. After two sails were badly damaged and subsequently removed around 1920, the mill managed with

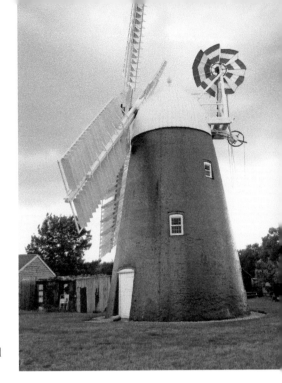

Button's Mill, Thelnetham, has been restored to full working order (2016).

only one pair before they too finally stopped turning in 1924. After George Vincent died in 1973 the mill acquired new owners who originally intended to convert it to residential use. This plan thankfully failed to come to fruition and it was then sold to a consortium of mill enthusiasts led by Peter Dolman in late 1979.

Button's Mill still carried the remnants of its sails and stocks but had lost its cap and fantail before a lengthy programme of restoration began in 1980. This lasted for seven years and saw the previously derelict shell transformed once more into a fully working windmill. A new 'pepper-pot' cap was hoisted into position by crane in October 1983. Two new stocks and four double patent sails were made and installed in 1984 and the new sails turned for the first time later that year. Much additional work was required before the project was finally completed in 1987. The new owners plus an army of volunteers did much of the work, assisted by windmill experts. The restoration cost was largely met by grants and donations from various sources.

Today Button's Mill is still retained in working order and is one of Suffolk's finest remaining tower windmills – and also one of its best kept secrets! It is small for a tower corn mill, having only four floors and measuring just 31.5 feet (9.6 metres) to the curb. The cap is relatively tall and is claimed to add 13.5 feet (4.11 metres) to the height of the tower including a finial. The comparatively large sails have a diameter of 64 feet (19.51 metres) and the brightly painted fantail has eight blades. Two pairs of French burr millstones can be found on the first floor and are driven by wind power. An additional pair on the ground floor is operated by a refurbished Ruston & Hornsby diesel engine installed in 1984. Since 2013 the mill has been run by Suffolk Building Preservation Trust (SBPT), which is in the process of upgrading facilities at the site. A new engine shed and a tearoom have recently been built and a granary was under

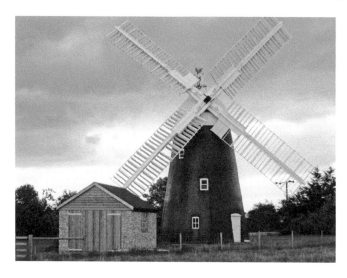

Storm clouds over Thelnetham Mill and its new engine shed (2016).

construction in 2017. The mill is open to the public on several dates during the year and stoneground flour is on sale to visitors.

NORTH-EAST SUFFOLK

Blundeston Tower Mill

Location: Mill House, The Street, Blundeston, near Lowestoft, NR32 5AQ. Privately owned and not open to the public.

Blundeston Mill was the work of millwright Robert Martin and was built for Ben Jackson around 1820. It was equipped with a boat-shaped cap, four patent sails and a fantail. This was another relatively small corn mill with four floors and housed two

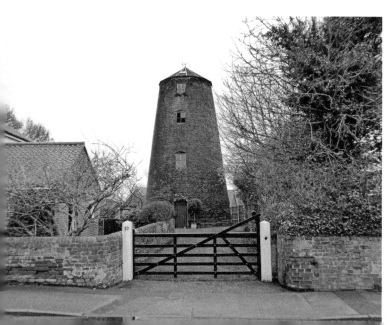

Blundeston Mill near Lowestoft (2017).

pairs of stones. The mill and adjacent Mill House were purchased in 1841 by Thomas Cooper, a miller and baker. He was a well-known figure in the village until his death around the turn of the century, after which his sons, George and Arthur, took over the family business. The mill's sails were dismantled after it ceased work in the early 1920s and its condition slowly deteriorated over the decades. By the late 1950s the tower was roofless but this was finally rectified in 1981 when the then owner Patrick Paul constructed a new roof. After his death the mill acquired new owners in 2003. It stands in a private garden and remains a well-known local landmark in the village.

A drainage mill is known to have existed on Blundeston Marshes in the nineteenth century. Blundeston was the fictional birthplace of the title character in Charles Dickens' novel *David Copperfield* and David is depicted on the village sign.

Corton Tower Mill

Location: Mill Lane, Corton, NR32 5HG (approx. 3 miles north of Lowestoft). Privately owned and converted to residential use.

Corton Mill was a typical six-storey tower corn mill with a boat-shaped cap, four patent sails and a six-bladed fantail. The sails each had ten bays of three shutters and the red-brick tower housed two pairs of millstones. The mill was in full working order in 1910 but is said to have fallen silent before the outbreak of the First World War. The sails and cap were later dismantled and the internal machinery was removed. The tower was truncated to five storeys and a new roof replaced the cap. After being used as a store for a number of years it was finally converted to residential use. Today it stands surrounded by houses but is still visible from various vantage points in the locality.

The coastal village of Corton has become a suburb of Lowestoft and is popular with modern holidaymakers as the home of a large amusement park. The most historic and atmospheric building is the partially ruined St Bartholomew's Church with its roofless and windowless tower. For a number of years Corton was well known for having an authorised naturist beach – though it has now been stripped of its official designation!

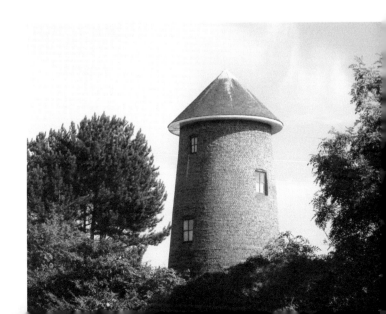

Corton Mill near Lowestoft (2016).

SOUTH-EAST SUFFOLK

Skoulding's Tower Mill, Kelsale

Location: Tower House, Rosemary Lane, Kelsale-cum-Carlton, near Saxmundham, IP17 2QT. Privately owned and converted to residential use.

Along with Burgh Mill and Buttrum's Mill at Woodbridge, Skoulding's Mill at Kelsale is one of the tallest remaining tower mills in Suffolk. All three were built by John Whitmore & Son of Wickham Market, who also erected several others in the county. Like Burgh Mill, which is a little taller to the curb, Skoulding's Mill has seven floors – one more than Buttrum's Mill. It was built for Kelsale millers Messrs T. & J. Skoulding in 1856 and stood 55 feet 2 inches (16.81 metres) tall to the curb, plus an ogee cap with a gallery. The total height including finial was probably around 68 feet (20.73 metres). The mill was equipped with a six-bladed fantail and four double patent sails that drove three pairs of stones. The tower has since lost its cap but appears to have retained all seven floors intact. The interior diameter at ground level is said to be 21.5 feet (6.55 metres), which is not a lot for a relatively tall mill. Externally the ground and first floors of the tower are tarred and the remainder are painted white.

A post mill already existed on the same site and for a while the two windmills worked together. The tower mill stopped working by wind around 1905–10, when the decision was made to install modern roller milling machinery powered by a steam engine. The cap was replaced with a flat roof during the 1950s, after which the machinery was taken out and the tower eventually converted to a private residence. The building is located away from the village of Kelsale on a narrow and winding country lane.

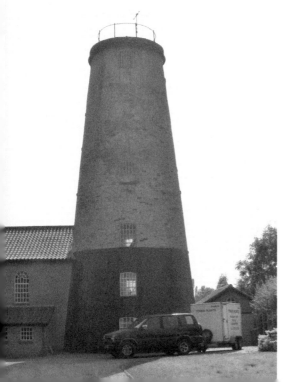

Skoulding's Mill, Kelsale, is one of Suffolk's tallest surviving tower mills (2016).

Fort Green Tower Mill, Aldeburgh

Location: Fort Green, Aldeburgh, IP15 5DE. Privately owned and converted to residential use.

The tower of this former corn mill stands adjacent to the beach at the southern end of the very popular seaside resort of Aldeburgh. Today it forms part of a much larger private residence, with various additions having been made over the years. It is still recognisable as a windmill but bears little resemblance to its younger self. It first became a home in 1902 – well before it became commonplace to convert old windmills to fulfil this role – when it was purchased by a clergyman. His wife was a Dane and this explains the biblical inscription in Danish that adorned an exterior wall. The mill's cap was painted light green for many years but is now black. An addition to the house said to be a gun tower was erected during the Second World War, when the building was utilised as an observation post. The whole property including the mill was advertised for sale in 2016 with a guide price of £1.2 million. After apparently finding a new owner it was renovated later that year.

Fort Green Mill was built in 1824 and during its working days had four floors plus a dome-shaped cap, a six-bladed fantail, four patent sails and a cast-iron windshaft. It appears that at some point during the 1890s it suffered catastrophic damage to the sails and never worked again. Although its physical location has not changed, the mill would originally have been quite a bit further inland than it is today. A village named Slaughden once stood to the south of Aldeburgh but gradually disappeared beneath the waves during the late nineteenth and early twentieth centuries. A Martello Tower built as a coastal fortification in 1810 can still be seen south of the old mill.

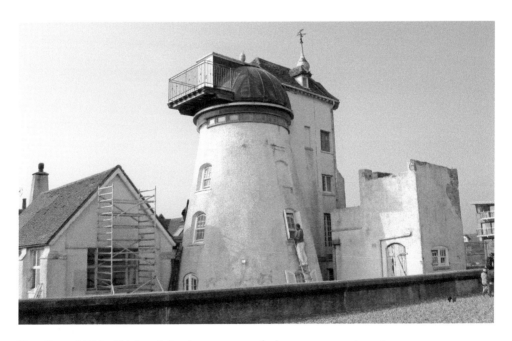

Fort Green Mill in Aldeburgh has become part of a larger property (2016).

Burgh Tower Mill

Location: Mill Hill, Burgh, near Woodbridge, IP13 6PU. Privately owned and converted to residential use.

Burgh Mill stands high on a hill overlooking the village, yet from some positions it is surprisingly well hidden. On climbing the hill to view the mill at close quarters its true size becomes apparent. Though not a giant compared with some of its enormous contemporaries, it is nevertheless Suffolk's tallest surviving mill tower and was probably the largest built by John Whitmore & Son of Wickham Market. The seven-storey tower stands 56 feet 7 inches (17.25 metres) tall to the curb and since restoration in 2004 has had a replacement ogee cap complete with finial. This should give a total height of around 70 feet (21.34 metres), compared with 61 feet (18.59 metres) for Buttrum's Mill at Woodbridge (*see* below). Both mills were built by the same firm of millwrights, as was the tall mill at Kelsale described earlier.

Francis Buttrum was Burgh Mill's first owner and miller in 1842, when it was built to replace a smaller tower mill. In its working days it had four patent sails and a six-bladed fantail. The original ogee cap was fitted with a decorative iron handrail. The

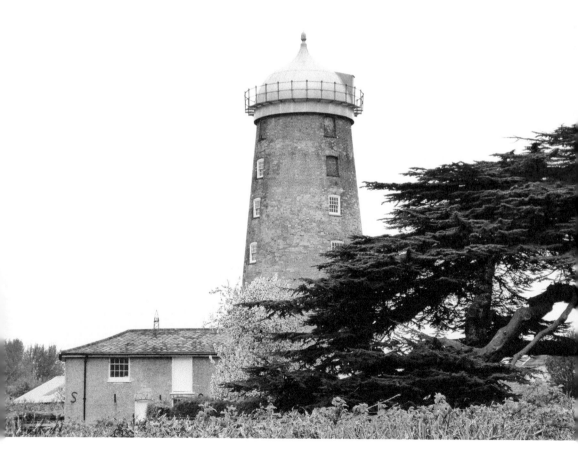

Burgh Mill has the tallest tower of any windmill still standing in Suffolk (2017).

tower, which has an internal ground floor diameter of 23 feet 2 inches (7.06 metres) with brickwork 30 inches (0.76 metres) thick, had four pairs of millstones on its third floor. A granary was attached to the tower and an 8-hp oil engine was later added. By 1922 the sails had ground to a halt and were subsequently removed. The remaining machinery was taken out by millwright Amos Clarke in 1925. Like several others, Burgh Mill was given a new use as an observation post during the Second World War. It was finally vacated by the Royal Observer Corps in 1960 when they moved to new underground premises. The empty tower was derelict until its conversion to residential use in the early twenty-first century. In 2015 the building was listed along with other East Anglian mills on Historic England's Heritage at Risk register.

Buttrum's Tower Mill, Woodbridge
Location: Burkitt Road, Woodbridge, IP12 4JJ. Privately owned and maintained by Suffolk County Council. Car parking is available close to the mill and the exterior can be viewed at any reasonable time. The interior can be viewed on open days only.

Buttrum's Mill is the tallest windmill in Suffolk still in working order. The six-storey red-brick tower measures 48 feet (14.63 metres) to the curb and 61 feet (18.59 metres) to the top of the finial on the ogee cap. It gives the impression of being taller than it actually is, probably due to its relatively slim tower, which has an internal diameter of 20.5 feet (6.25 metres) at the base tapering to 11 feet (3.35 metres) at the summit. The brickwork is 23 inches (0.58 metres) thick at ground level and the diameter of the four patent sails is 70 feet (21.34 metres).

Built by the Wickham Market millwright John Whitmore, Buttrum's Mill takes its name from a Suffolk milling family, who operated it for many years, but was originally known as Trott's Mill. According to more than one source it was built in 1816–17, though others give a later date of 1836. Following the death of owner Pearce Trott the mill became the property of Captain William Trott, who leased it to various millers including William Benns, Charles Williams and, in 1869, John Buttrum. After he died in 1884 his wife Mary Ann Buttrum took over. Their son George assisted in running the mill for a number of years before taking charge around 1908 until it stopped work in late 1928. The mill, mill house and outbuildings had changed hands in 1877 following the death of Captain Trott, the new owner being Mr. C. Stevenson, who paid the princely sum of £1,000 at auction. A portable steam engine was added at the site during the 1880s.

After being purchased in 1937/8 by windmill enthusiast Mr. C. Kenney, Buttrum's Mill finally underwent extensive restoration between 1952 and 1954. The cap had been damaged during the 1940s when the fantail was blown down. East Suffolk County Council took a long-term lease on the mill in 1950 and the work was carried out by Norfolk millwrights Thomas Smithdale & Sons. This included replacing the cap, fantail and gallery. The corroded iron gallery rail around the outside of the cap was superseded by a plainer wooden version. The total cost of this work was almost £4,000, mainly funded by the County Council but helped by a donation of £800 from the Pilgrim Trust. The fantail was repaired following gale damage at the end of 1966 and additional renovation was needed four years later. A new sail and stock were

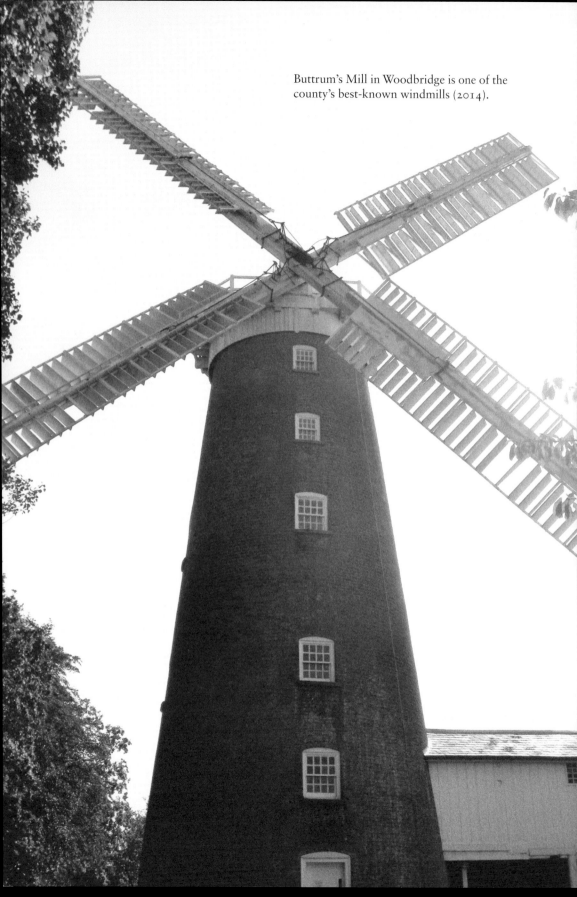

Buttrum's Mill in Woodbridge is one of the county's best-known windmills (2014).

installed in January 1973. Further work was required later that decade and into the first half of the following one. Another new cap was put in place in 1982 and was followed two years later by more new sails. For the first time in many years the mill was brought back to working order. It still retains all its machinery including four pairs of stones each 4 feet (1.22 metres) in diameter and a cast-iron great spur wheel.

Until his death, aged ninety, in September 2016 the mill was owned by Martin Whitworth, who purchased it along with the mill house in 1969. Today the mill continues to be maintained by Suffolk County Council and essential repairs were carried out in September 2013, including work on the sails, fantail and windows. Buttrum's Mill is one of the county's finest tower mills and is open to the public on some weekends and bank holidays between Easter and the end of September.

Tricker's Tower Mill, Woodbridge

Location: Mussidan Place, Theatre Street, Woodbridge, IP12 4NE. Privately owned and converted to residential use.

Although overshadowed by Buttrum's Mill and the famous Woodbridge Tide Mill (*see* chapters 5 and 6), the converted tower of Tricker's Mill is of historical interest and adds to the character and diversity of the town.

Named after its last miller, the five-storey red-brick mill was built around 1815–18 and had four patent sails and a six-bladed fantail. The cast-iron windshaft was second hand, having come from a post mill. The tower housed three pairs of millstones and was originally topped with a dome-shaped cap. After this was blown down in January 1881, it was superseded by a boat-shaped cap with petticoat and gallery. The tower has an internal base diameter of 21 feet 4 inches (6.49 metres) and measures 42 feet 8 inches (13 metres) high to the curb. A brick on the exterior carries the inscription: 'W. Mower Feb. 2 1835'. Mr Orsborn was recorded as the owner from the early 1840s until at least the mid-1850s. Other millers included William Benns (1860s) and Alfred

Tricker's Mill, Woodbridge, now converted to a residence (2014).

Read (1880s/90s). Mr J. S. Tricker was in charge when the mill's sails finally drew to a halt around 1920 after more than a century. Like many others, this mill probably switched to grinding animal feed in its later working years.

The mill remained complete until the 1950s when it was partially dismantled. The cap and windshaft were removed but most of the internal machinery was untouched. One pair of millstones was reused elsewhere. The tower retained its five floors and a new flat roof was fitted. After becoming derelict, Tricker's Mill almost disappeared from the Woodbridge skyline in the early 1970s when a sheltered housing development on the site was approved. Suffolk Mills Group campaigned for the mill to be fully restored to working order but for a while its very existence was in doubt. In the end a compromise was reached whereby the new housing would be built around it with the tower remaining as the centrepiece of the development. The building was sensitively renovated leaving almost all of the machinery in place and partially converted to residential use. The ground floor became a common room-cum-television lounge while the first floor served as a bedroom for guests. An external spiral staircase was constructed to provide direct access to this floor. Tricker's Mill was part of the Mussidan Place sheltered housing complex from 1975 until 2009. In October 2011 it was advertised for sale as a single-bedroom detached house with a guide price of £100,000. It was described as being in need of 'extensive specialist restoration' and the upper-floor timbers were said to require repair.

In addition to Buttrum's and Tricker's, Woodbridge was once home to several other windmills. Lockwood's Mill on Victoria Road was another tower mill and was built around 1825 to grind clinker for cement. It stopped working by wind following severe gale damage in 1841. A post mill is thought to have once stood close to Tricker's Mill and four others of this type worked together on Mill Hill before three were dismantled and rebuilt at other sites in 1841/42. The fourth remained in place and finally stopped work in 1866.

MID-SUFFOLK

Clover's Smock Mill, Drinkstone

Location: Woolpit Road, Drinkstone, near Bury St Edmunds, IP30 9SP. Privately owned and not open to the public.

Together with its post mill neighbour (*see* chapter 2), this interesting smock mill was one of two Drinkstone mills owned and run by several generations of the Clover family. The two-storey wooden body is eight sided and was constructed around 1780 on a single-storey brick base originally built as a horse mill in 1689.

Drinkstone Smock Mill had a wooden windshaft and a 'pepper-pot' cap. The mill was originally turned into the wind by means of a chain and wheel but was later equipped with a fantail. The millstones were mounted on a Hurst frame. When the sails were removed around 1900, two were the common type and two were the spring type. The smock mill continued to be worked by means of an oil engine into the second half of the twentieth century following damage to the post mill. Both mills were sold in 1997, finally severing their long association with the Clover family.

Clover's Smock Mill, Drinkstone, was built on the base of a horse mill (2017).

Hitchcock's Tower Mill, Rattlesden

Location: Mill House, Mill Lane, Rattlesden, near Stowmarket, IP30 0SQ. Privately owned and not open to the public.

Mill Lane on the outskirts of Rattlesden was an important commercial milling site from the late eighteenth century until at least the 1930s. Post, smock, tower and steam mills existed here at various times and the remains of two still exist.

Hitchcock's Tower Mill is believed to have been built between 1840 and 1850 by Wickham Market millwright John Whitmore. It was equipped with an ogee cap and finial, a fantail and four patent sails, which drove two pairs of millstones. It may have been built for miller Robert Winson, who operated the smock mill opposite (*see below*) and another mill elsewhere in the village until at least the mid-1840s, but this is uncertain. John Clover appears to have acquired both Mill Lane mills during the 1850s and he was still listed as miller in the mid-1870s. For at least part of this time he was assisted by another miller named Henry Pike.

Ralph Hitchcock was first recorded at the site in the mid-1880s and the tower and smock mills together became known as Hitchcock's Mills. The tower mill switched over to grinding feed for animals before it finally stopped work in the mid-1930s. It was stripped of its sails and cap before being used as an observation post during the Second World War. For a number of years the tower mill has been owned by David Blackburn, who considers it likely that the nearby Mill House was also built by John Whitmore around the same time as the mill. As neither building is dated or carries a builder's mark, conclusive evidence is lacking. Mr Blackburn informed me that the five-storey tower was reduced in height when the cap was taken down. Several feet of brickwork and the top-floor window were removed and a new flat roof was fitted. Some of the machinery is still in place including one pair of stones but the other pair was removed in the 1970s and reused at a Sussex watermill. The tower is unusually slender and although now truncated and disused, it still has character.

Another tower mill also owned by Ralph Hitchcock existed on Mill Hill in Rattlesden from around the middle of the nineteenth century until 1919, but seems to have ceased work before 1900.

Hitchcock's Tower Mill, Rattlesden, near Stowmarket (2017).

Hitchcock's Smock Mill, Rattlesden

Location: The Smock Mill, Mill Lane, Rattlesden, near Stowmarket, IP30 0SQ. Privately owned and converted to residential use.

Hitchcock's Smock Mill stood opposite the surviving tower mill described above. The smock mill replaced a post type known to have been in existence by 1782. This was advertised for sale by William Nunn in 1805 and again in March 1818, by which time Mr T. Winson was its owner. The smock mill was probably constructed later in 1818 or the following year. A three-storey wooden smock tower was attached to a single-storey brick base and the cap was dome-shaped. To the top of its finial the mill was around 45 feet (13.72 metres) tall. The weatherboarding was painted white and the mill was fitted with a fantail and four patent sails. It may have had as many as six pairs of stones but some of these would have been powered by a steam engine added later.

Robert Winson was listed as owner and miller during the 1830s and '40s and he also owned another mill at Mill Hill, Rattlesden. John Clover had taken over by the late 1850s and he was still there in the mid-1870s. During the 1880s both mills were being run by millers Ennals and Hitchcock but by the early 1890s Ralph Hitchcock was in sole charge. A steam mill had been added by this time but both the smock and tower mills were still working by wind. The smock mill was dismantled early in the twentieth century but its brick base was retained as part of a larger roller mill complex. The wood from the smock tower was reportedly recycled inside the new building.

The base of Hitchcock's Smock Mill forms part of this building now converted to residential use (2017).

In the early twenty-first century the redundant power mill building was converted to residential accommodation and named the Smock Mill. Though now completely transformed, this building and its tower mill neighbour serve as reminders that this picturesque corner of rural Suffolk has a rich milling heritage.

Buxhall Tower Mill

Location: Mill Road, Buxhall, near Stowmarket, IP14 3DW. Privately owned and converted to residential use.

In its prime Buxhall Mill was one of Suffolk's most powerful windmills. The four patent sails each had eleven bays of shutters and were equipped with air brakes. The total sail diameter of 80 feet (24.38 metres) was not far short of the 84-foot (25.6-metre) span of the mighty Southtown High Mill (*see* chapter 1), which was much taller. The dome-shaped cap of Buxhall Mill had an external gallery and was one of the county's largest at 14 feet (4.27 metres) high and 17.5 feet (5.33 metres) in diameter (measured internally). A cast-iron windshaft was used and the fantail was an eight-bladed type. The six-storey tower is unusual in that the first three storeys are octagonal and the upper three are round. This is because the present tower mill built in 1860 was not new from the ground up but was constructed on the substantial base of a smock mill dating from forty-five years earlier. Even this was not the first mill on the site as a post mill existed here from around 1783 to 1814, when it burned to the ground. This was possibly a deliberate act but a tall smock mill emerged from the ashes of its predecessor just a year later. It was built by Suffolk millwright Samuel Wright and a steam mill was added on the premises during the 1850s.

Buxhall Tower Mill was the work of millwright William Bear of Sudbury. The wooden smock body was taken down and much of the machinery, including the sails and cap, was reused in the tower mill. The work was completed in early 1861 and the

Buxhall Tower Mill behind a converted Methodist chapel (2017).

new mill had five pairs of stones, all of which were removed during the 1940s. The mill worked by wind until it was severely damaged in a gale in November 1929, though it continued to operate with an oil engine until 1971.

Happily, Buxhall Tower Mill is still standing in the village and is a local landmark. It has been converted to a private residence and is situated close to a former Methodist chapel built in 1873. The mill and other buildings on the site were offered for sale in 2017.

WEST SUFFOLK (NORTH TO SOUTH)

Bardwell Tower Mill

Location: School Lane, Bardwell, IP31 1AD (approx 2 miles north of Ixworth). Privately owned and open to the public on some days only.

In recent years Bardwell Windmill has been transformed by the fitting of a new set of sails and other work carried out by volunteers. It was probably built in 1823 as that date is recorded on a beam inside the mill. The tower mill replaced an earlier post type but the first mention of a windmill in Bardwell was in the late thirteenth century.

The present Bardwell Mill has four floors plus a beehive-shaped cap and its new patent sails have a diameter of 63 feet (19.2 metres). Two pairs of overdrift millstones are driven by a wooden great spur wheel. The mill worked by wind for just over a century before a Blackstone oil engine took over between 1925 and 1941. The derelict tower was bought in 1979 by James Waterfield, who set about restoring it to full working order. Milling resumed by wind in 1985 and the working mill was later sold to Geoffrey and Enid Wheeler, who relocated to Suffolk from Buckinghamshire

Bardwell Mill has been restored to full working order (2017).

in 1987. They had only owned it for a few months before disaster struck in the form of the infamous great storm of 16 October 1987. The newly restored mill was tail winded and the sails and fantail were blown off the tower. Thankfully the mill house was spared but the sails came down on a greenhouse and also damaged a steam engine owned by Mr Wheeler. Local volunteers came together in 1997 to form the Friends of Bardwell Windmill, though some repairs had been carried out during the late 1980s and early '90s. Much restoration work took place in the early twenty-first century at an estimated cost of nearly £100,000, the bulk of which was met by grants with the remainder coming from donations.

Major work included replacing the cap, fantail, sails and windshaft. The first pair of sails was fitted towards the end of 2010 with the second following in spring 2012. They started turning shortly afterwards and Bardwell Mill rejoined Suffolk's depleted ranks of working windmills.

Pakenham Tower Mill

Location: Thieves Lane, Pakenham, IP31 2NF (south of the A143 approx. 5 miles north east of Bury St Edmunds). Privately owned and open to the public 'during normal working hours' (parties by appointment).

One of Suffolk's finest surviving tower mills, Pakenham Windmill has five floors plus its domed cap complete with a gallery and topped with a finial. It still has all four patent sails and an eight-bladed fantail. The tarred brick tower once housed three pairs of millstones of which two pairs remain.

Constructed in 1831, this well-known local landmark was owned by John Aldrich in the 1840s and worked by a miller named Clement Goodrich. It has been associated with the Bryant family since 1885. The mill came close to being tail winded (when the

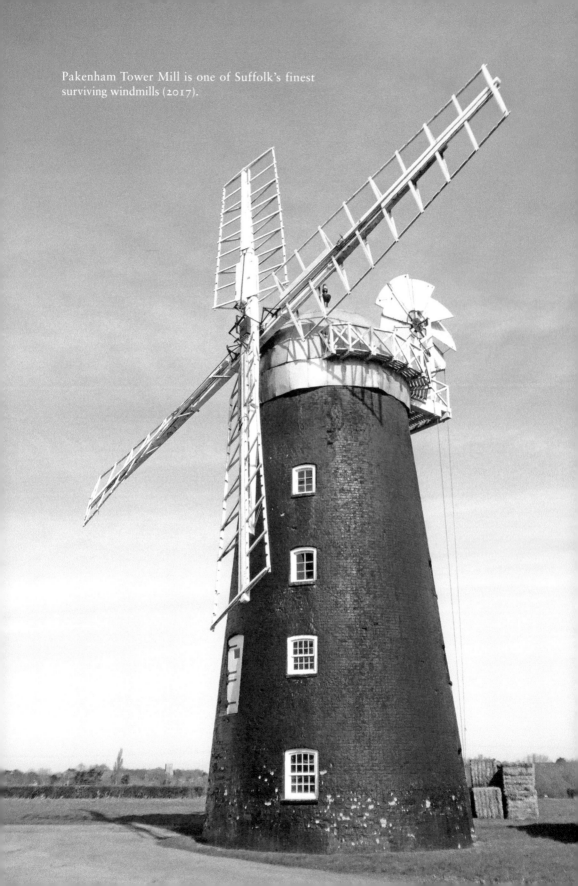

Pakenham Tower Mill is one of Suffolk's finest surviving windmills (2017).

sails are hit from behind by a sudden gale) in 1947 but owner John Bryant skilfully avoided this by quickly turning the cap to face the wind. Many mills were badly damaged due to being tail winded and quite often never worked again. Having avoided this fate, Pakenham Mill nevertheless required considerable repairs in 1950 including the fitting of new sails and a replacement stock (from Thurston Post Mill). A new weather beam was also needed along with a 'swing-pot' neck bearing and brass, which had been removed from Buxhall Mill after storm damage in 1929. At or around this time a wooden gallery was installed around the cap. All of this work was carried out by millwright Amos Clarke with assistance from his son Alf.

Much additional renovation was necessary in the early 1960s, at a cost of over £4,000. The Ministry of Works and the County Council agreed to pay £2,000 each and the work was completed by Alford millwrights R. Thompson & Sons. This included fitting two more new sails and a new stock, plus extensive repairs to the fantail and cap. The latter was originally clad in copper but this was replaced with aluminium as part of the rebuild. A lightning strike in June 1971 resulted in further damage to a sail and stock. Repairs costing nearly £1,000 were eventually carried out around ten months later. The mill has been regularly maintained since then and major restoration (again carried out by R. Thompson & Sons) took place in May 2000 at a cost of £60,000, most of which was provided by the Heritage Lottery Fund. The mill was returned to full working order, but the shutters were removed from the sails for safety reasons in September 2016.

It has been stated that Pakenham Windmill stands 80 feet (24.38 metres) tall, which may be the total height including sails. The village is also rightly proud of its impressive working watermill (*see* chapter 6).

Gazeley Tower Mill

Location: Mill Road, Gazeley, CB8 8RW (off the A14 approx. 6 miles from Newmarket and 9 miles from Bury St Edmunds). Privately owned and converted to residential use.

Before the present tower mill was erected a post mill existed in the village of Gazeley. This was worked for many years by a Mr Death, and his son William built the tower mill close by in 1844. The new mill was fitted with four patent sails, a six-bladed fantail and five pairs of millstones. Three pairs could be operated by a Gippeswyk oil engine installed in 1880 to provide auxiliary power. This was manufactured and supplied by E. R. & F. Turner, an Ipswich based firm of milling engineers.

Gazeley Tower Mill was bought by R. J. Harvey after William Death passed away in 1893. Mr Harvey, who remained at the mill until at least 1910, invested in a roller mill powered by the existing oil engine. Roller milling, which utilised metal rollers in lieu of millstones, was a relatively new development and produced finer flour. It too was made by Turners of Ipswich and only just fitted inside the tower. Two pairs of millstones continued to be used but only for animal feed. Gazeley Mill worked until shortly after the end of the First World War and the machinery was removed before it became a private residence in 1947. The sails and cap were taken down and a simple flat roof was put in place. The tower now has five floors but is said to have originally had six.

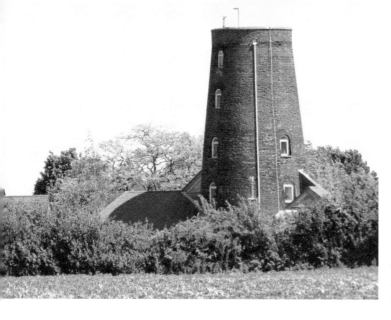

Gazeley Mill as viewed from a public pathway off Mill Road (2017).

The former mill, complete with modern extensions, was recently advertised for sale as a five-bedroom detached house. From the roadside it is well camouflaged but can be viewed at a distance from a public pathway leading from Mill Road.

Lower Smock Mill, Dalham

Location: Stores Hill (B1085), Dalham, CB8 8TQ. Privately owned and not open to the public.

Lower Mill, Dalham, near Newmarket, is situated almost on the boundary with Cambridgeshire and only just qualifies as a Suffolk mill. It is four stories tall – one in the brick base and three in the smock tower – plus a 'beehive' cap complete with a gallery and finial. The total height from ground level to the top of the cap is around 50 feet (15.24 metres), which almost certainly makes it Suffolk's tallest remaining smock mill. Also sometimes known as the Opposition Mill, it was built not long after

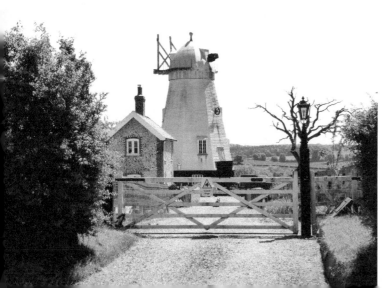

Dalham Lower Mill is located almost on the boundary with Cambridgeshire (2017).

a similar smock mill in Ashby, just over the border in Cambridgeshire. Upper Mill, as it was known, burned down in the 1960s.

Dalham Lower Mill was probably constructed for William Ruffle during the 1790s but temporarily lost its sails in a gale in 1802. Two men working there at the time narrowly escaped injury, but after new sails were fitted the mill continued to work until at least 1926. George Moore became miller after the death of William Ruffle in 1855 and he stayed there for twenty years. During this time he is said to have also operated Upper Mill. A miller named J. Dunning, who was probably an employee of George Moore, was also recorded at Lower Mill in the late 1850s and mid-1860s. Moore was followed by Abraham Simpson, who around a decade later was superseded by Joseph and John Tabraham. Lower Mill then remained in the Tabraham family until the early 1900s, when Elijah Rutterford became owner. His tenure was quite brief and by 1908 Charles Kerridge was in charge. Messrs Robinson and Turner were listed at the Lower Mill in 1926, and it ceased work around this time.

During its productive life the mill had four patent sails driving three pairs of underdrift millstones supported by a Hurst frame, a heavy wooden structure mainly found in water mills but also used in some Suffolk windmills. Each sail was 27 feet (8.23 metres) in length and 7 feet (2.13 metres) in width. After falling into a state of disrepair the mill was restored in the late 1930s, but was again in need of much work when Frank Farrow bought it in the early 1970s. After considerable delays the mill was finally restored in 1979–81 by millwrights Gormley and Goodman. A new curb was required at the top of the wooden tower before other work could be carried out. New sails were fitted as part of the restoration and it was hoped that the mill would work again. This did not happen and today the mill has no sails or fantail but otherwise appears to be in good condition.

Collis Smock Mill, Great Thurlow

Location: Withersfield Road, Great Thurlow, CB9 7LE. Privately owned and not open to the public but the exterior can be viewed at any reasonable time.

Collis Mill at Great Thurlow near Haverhill is also close to the border with Cambridgeshire and was probably moved from Slough, Berkshire, around 1807. This little smock mill is four storeys high including the brick base and takes its name from the last miller on the site. The present mill replaced a post mill and had four common sails, a 'pepper-pot' cap and an eight-bladed fantail. The sails drove two pairs of underdrift millstones.

Little is known about the mill's early life but Thomas Gardner was the owner in the early 1840s. After his death around 1845 the mill was bought by Joseph Dearsley, who continued to employ a miller named James Talbot, who had previously worked for Thomas Gardner. Talbot left Great Thurlow Mill at the end of the 1840s when Elijah Dearsley became the new owner and miller. He worked the mill for around a quarter of a century and later millers included Archibald Robinson, Gabriel Savage and, finally, Joseph Collis. It changed hands for the last time as a working mill in the early 1900s and continued to work by wind for a number of years. A portable steam engine provided supplementary power from 1908 and later took over completely until the mill closed in 1937. All four sails had been taken down by 1924.

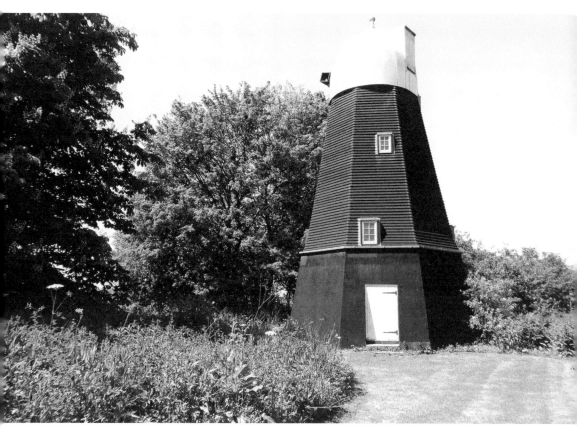

Collis Mill, Great Thurlow, has recently been restored (2017).

Following Joseph Collis's death in 1959 the mill was fully restored by Ronald Vestry of Great Thurlow Hall but was not put back to work. The weatherboarding on the smock body was replaced, as were the sails, fantail and cap. The project was finished in 1962 but additional work including repainting was necessary twelve years later. The latest major restoration was undertaken in 2011, which again included replacing the weatherboarding and much other work. The decayed sails and fantail were taken down and have not been replaced. The cap is now clad in aluminium, which gives it a distinctive appearance. Collis Mill, which is still owned by the Thurlow estate, stands on land off Withersfield Road and the exterior is accessible to the public.

Chilton Street Tower Mill, Clare

Location: Folly Road, Chilton Street, Clare, CO10 8RR. Privately owned and not open to the public.

Chilton Street Mill is a stark but atmospheric ruin that stands alone in a field near Clare in south-west Suffolk, not far from the border with Essex. It has no roof and vegetation growing inside the otherwise empty shell appears to be attempting to escape through a gaping hole in its wall.

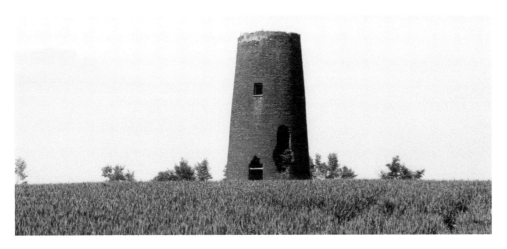

The lonely ruined tower of Chilton Street Mill stands in a field near Clare (2017).

The mill was built in the 1840s and is known to have been fully operational forty years later. It never worked again after losing its sails during a gale, probably in the early twentieth century. All machinery had been removed by the 1930s. During its productive life Chilton Street Mill was equipped with two pairs of millstones, four patent sails, a fantail and a dome-shaped cap.

OTHER TOWER AND SMOCK MILL REMAINS

In addition to those featured above, Suffolk has other tower and smock mill remains ranging in condition from derelict to full residential conversions. A number have been severely truncated and now serve as sheds or stores. Several smock mill bases (minus their timber smock towers) have been converted to homes. Tower and smock drainage mills are included in chapter 4.

The much-altered tower of Lound Mill still stands on Yarmouth Road, Lound, near Lowestoft, NR32 5LZ. Built by Robert Martin in 1837, it had four patent sails, a fantail and three pairs of stones. It worked by wind until 1939 and lost its machinery before becoming a private residence c. 1961, when it acquired a rather curious replacement cap.

Stansfield Tower Mill is located in a private garden on Plough Hill, Stansfield, CO10 8LT. The five-storey tower still contains some machinery but has lost its cap and sails and now has a flat roof. It was built in 1840 but was no longer in use by the early 1920s.

Tutelina or Clarke's Tower Mill stands in a very rural location south of Bury St Edmunds on Stanningfield Road, Great Welnetham, IP30 0UB. It was built in 1865 and last worked by wind in 1910, but remained in use under engine power until the 1960s. The four-storey tower now has a flat roof in place of the original dome-shaped cap.

Cockfield Tower Mill replaced an earlier one called Pepper Mill. The present four-storey mill was built in 1891 but had a short working life of around ten years.

It has been extensively modified and converted to residential use and is available for holiday lets. The mill is located on Lavenham Road (A1141), Cockfield, IP30 0HX.

Crowfield Smock Mill near Stowmarket (IP6 9SZ) began life as a windpump near Great Yarmouth before being moved to Crowfield around 1840. Two pairs of underdrift millstones were then fitted as part of its conversion to a corn mill. It worked until the 1930s, latterly with an engine after losing its cap and sails during a storm in 1916. It was restored from a derelict state in 1984 but has no sails or fantail.

Walton Upper Mill still stands on High Street, Walton, Felixstowe (IP11), but has no cap, sails or machinery. The four-storey smock mill was erected in 1804 and partially dismantled around a hundred years later. A corrugated iron roof was fitted at this time. The weatherboarding on the smock tower was repaired in the late 1990s.

The smock body and cap of Cransford Mill were moved to Peasenhall in the mid-1880s to become part of a power mill. It worked by wind at its original location from the 1830s but the sails were not required at its new home. The smock body and a post mill roundhouse still stand in a private garden off Mill Road, Peasenhall, IP17 2LJ.

A smock mill tower and a post mill roundhouse still survive at Peasenhall (2017).

Chapter 4

Windpumps (Drainage Mills)

Several tower and smock drainage mills or windpumps still survive in Suffolk in various states of repair, though they are heavily outnumbered by corn mills. Most were built in the east of the county and Suffolk is also home to a very unusual example that started life as a traditional full-sized corn post mill before being converted to a hollow-post windpump. Thorpeness Mill may be unique in this respect as hollow-post windpumps were usually small purpose-built structures.

EAST SUFFOLK (NORTH TO SOUTH)

Herringfleet Mill

Location: Herringfleet Marshes, east bank of the River Waveney, between St Olaves and Somerleyton, approx. 5 miles north-west of Lowestoft. Owned by the Somerleyton Estate. Exterior can be viewed at any time and car parking is available by the side of St Olaves Road (B1074), NR32 5QT. Approx. 0.5 mile each way on a public footpath. Interior open to the public on selected dates only.

Herringfleet Mill was built in the 1820s or early 1830s by the millwright Barnes of Reedham and is situated just inside Suffolk very close to its border with Norfolk. It is a three-storey smock windpump or drainage mill with a tarred, octagonal wooden tower set on a few courses of brickwork. As it has no fantail the boat-shaped cap was manually steered into the wind by the marshman by means of a braced tailpole. Herringfleet is probably the last full-sized smock marsh mill in Britain still in full working order at its original location. It has four common sails covered in canvas and was once one of many drainage mills at work in the area. A scoop wheel 16 feet (4.88 metres) in diameter and 9 inches (0.23 metres) in width is located immediately behind the mill in a casing known as a hoodway. The sails sweep down almost to ground level and their diameter is far greater than the height of the tower. It is very similar in design and appearance to a traditional Dutch windpump and many still work in the Netherlands.

Life was not easy for the marshmen, particularly during bitterly cold winters when snow was on the ground. Often they worked through the night grabbing what sleep they could and trying to keep warm. Like several others, Herringfleet Mill was

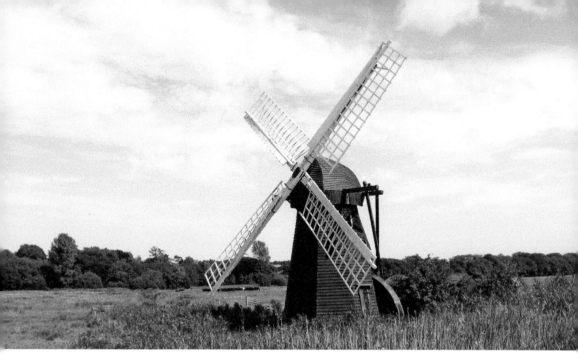

Above: Herringfleet Mill stands in splendid isolation on marshland near Somerleyton (2016).

Below: Herringfleet Mill is still operated by volunteers on open days (2016).

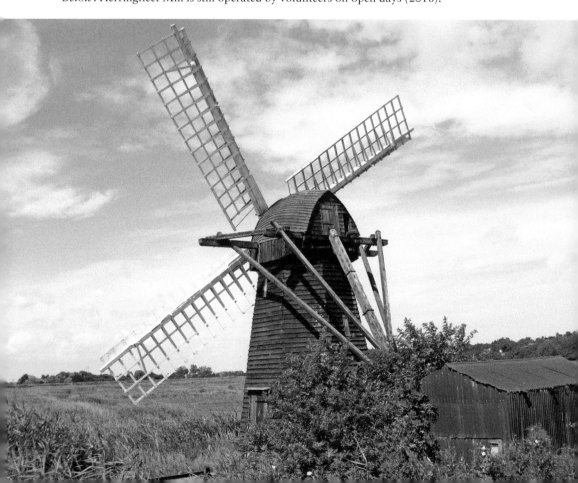

equipped with a fireplace and a hard wooden bench but creature comforts were minimal. During the 1880s the mill was no longer working but was later brought back to use. It continued to drain the marshes up to the mid-1950s when the scoop wheel was damaged. Drainage continued using a diesel pump. Sometimes known as Walker's Mill after marshman Jimmy Walker, Herringfleet was worked for up to forty years by Charlie Howlett, whose services were retained in the capacity of mill caretaker after it closed. For a number of years he continued to operate it on open days for the entertainment and education of visiting schoolchildren. Mr Howlett, who had a broad local accent and saw action during the First World War, later appeared on television and was in his eighties when he died in 1974.

During its working days Herringfleet Mill was the responsibility of the Somerleyton estate. They retained ownership when it was officially transferred to East Suffolk County Council in July 1958. By this time, millwrights Thomas Smithdale & Sons of Acle in Norfolk had carried out repairs to the scoop wheel and tailpole, and also retarred the mill's weatherboarding. The £500 cost was mainly met by the council and the Ministry of Works. Further restoration took place in 1971 when Beccles millwright Neville Martin replaced all the sails and carried out other work at a total cost of around £1,000. Periodical repair and maintenance has been undertaken since then and, wind permitting, the mill is still operated on open days. It remained the responsibility of Suffolk County Council until 2015, when it was returned to the Somerleyton estate. The mill cannot be seen from the road but motorists can park in a small area beside the B1074 between Somerleyton and St Olaves, near a gateway marked 'public bridleway'. It is well worth the 1-mile round trip past a field of inquisitive bovines to view it at close quarters.

Blackshore Mill, Reydon
Location: Reydon Marshes, Reydon, Southwold, IP18. Parking is available at Southwold Harbour. Follow pathways beside the River Blyth. The exterior can be viewed at any time.

Blackshore Mill, Reydon, had a very short working life of just a few years (2016).

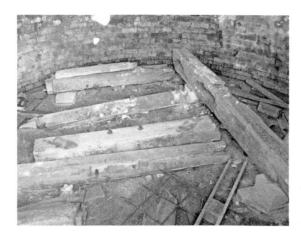

The ground floor of Blackshore Mill is still littered with debris from the collapsed first floor (2016).

The lonely tower of Blackshore Mill still stands beside the River Blyth near Buss Creek. It is visible from a distance in every direction but a little effort is needed to actually reach it. From the harbour car park at Southwold it is about a ten-minute walk along tracks and through various gates. When I visited on a warm but very blustery day in late summer it seemed an ideal location for a drainage windmill, though this one only worked for a few years before being badly damaged.

Blackshore Mill is a small three-storey brick tower windpump around 26 feet 3 inches (8 metres) tall to the curb. It originally had a boat-shaped cap with a fantail and – for a short period of time – four patent sails. In place of a scoop wheel this relatively late example employed a plunger pump. The mill was designed to help drain Reydon Marshes and was constructed around 1890 by Robert Martin. It appears that during the middle part of that decade the cast-iron windshaft broke and the sails plummeted to the ground. It is still something of a mystery as to why a virtually new drainage mill was simply abandoned instead of being repaired. Whether the reason was purely financial or if other factors influenced the decision is unknown. It soon became derelict and for many years was without a cap. Some repairs were carried out to the brickwork during the 1970s after a fund was started to try to preserve the rapidly deteriorating structure.

A new cap was finally installed in 2002 as part of a wider renovation but this did not include replacement sails or a new fantail. Today the ground floor is still covered in debris after the first-floor timbers gave way a number of years ago. This can be seen through a large aperture at the base of the tower. Much of the machinery is still in place but the plunger pump has been removed.

Old Water Tower Windpump, Southwold

Location: The Common, Southwold, IP18 6TB. The old water tower has been converted to office use.

The very popular seaside town of Southwold is dominated by its famous white lighthouse, which became operational in 1890 and is 102 feet (31.1 metres) tall. The old water tower on the common is less well known today but once had a large annular

A large circular sail was once mounted on the roof of Southwold Old Water Tower (2017).

(circular) sail perched on its roof. This sail, comprised of metal blades and resembling a giant fantail, was part of a Simplex wind engine manufactured by J. W. Titt, which pumped water to the tower from a nearby well. It was installed when the building was erected for the Southwold Water Co. around 1886 but it's unclear when the wind engine was dismantled. The sail increased the water tower's total height considerably but its actual dimensions do not appear to have been recorded. The old tower still exists minus its unusual appendage, but was superseded by a new art deco-style structure built beside it in 1937. For the record the new tower holds 150,000 gallons of water compared with its predecessor's 40,000-gallon capacity.

A tragic accident occurred at the old tower on 14 February 1899 when an employee named George Neller was killed after his coat became trapped in the pumping machinery. Since being decommissioned the building has had a number of different uses and owners. For many years it was the property of various water companies before Southwold Town Council acquired it in 1987 for the sum of £100. For a while it was used as a lifeboat museum and was also occupied by local brewers Adnams. Since 2005 the tower has served as a novel office for a lettings company and has undergone extensive restoration.

Southwold also once had another windpump, a little hollow-post structure with small cloth-covered sails, located at the town's salt works. Mainly of timber construction with some components made from iron, it utilised a plunger pump to lift water from a well and could also be operated by means of a handle. It was dismantled around the start of the Second World War and no trace remains.

Westwood Marshes Mill, Walberswick

Location: Westwood Marshes, Walberswick, near Southwold. Follow a footpath opposite Hoist Covert car park, Lodge Road, Walberswick, IP18 6UP. The exterior can be viewed at any time but the interior is not open to the public.

Above and below: The burnt-out tower of Westwood Marshes Mill, Walberswick (2017).

The isolated tower of this small windpump can still be seen on Westwood Marshes, just outside the popular coastal village of Walberswick near Southwold. It had three floors but measures just 23 feet (7 metres) tall to the top of the brickwork. Much of the interior was gutted by fire in October 1960, during which the cap and sails were also lost. After lying derelict for several decades and much debate over its future, there is now fresh hope that the mill may be restored if funds allow. Under the direction of East Suffolk Building Preservation Trust, inspections and preliminary repairs were carried out in 2014 and quotes were obtained for replacing the cap, tailpole, floors and other works. At the time of writing, however, no major work has been undertaken.

Westwood Marshes Mill is thought to have been built around 1798. It had a tailpole with a wooden wheel and a winch to enable the marshmen to turn the boat-shaped cap. The last two recorded marshmen were Jack Stannard, who left when the First World War broke out in 1914, and Bob Westcott, who took over until the mill stopped work in 1940. An external iron scoop wheel with wooden paddles was driven by four cloth-covered common sails on a cast-iron windshaft. Mills expert and author Rex Wailes stated that the scoop wheel had a total diameter of around 10 feet (3.05 metres) and part of it still survives. For a number of years the mill served a dual role as a grist mill, being equipped with a single pair of millstones. It was unusual for a drainage mill to have this capability, though it was restricted to grinding feed for farm horses.

The mill enjoyed a long working life and may have continued to operate for even longer but for the outbreak of the Second World War. During this conflict the tower, cap and sails were badly damaged by 'friendly' artillery fire during practice sessions at the remote location. Extensive repairs took place during the following decade to rectify this damage and hopefully preserve the mill in good non-working order. Unfortunately this work was undone by an apparent act of arson a few years later. Though now a burnt-out shell, the tower still stands out against the reed beds and dykes. It is close to a public footpath across the Westwood Marshes through part of the Suffolk Coast National Nature Reserve, run by Natural England.

Thorpeness Mill

Location: Uplands Road, Thorpeness, near Leiston, IP16 4NQ. Privately owned and open to the public on some dates between Easter and September only. The exterior can be viewed at any reasonable time.

The coastal holiday village of Thorpeness as it appears today is the relatively recent realisation of one man's slightly whimsical dream. Scottish barrister, author and landowner Glencairn Stuart Ogilvie transformed the former fishing hamlet into a fantasy village of grandiose and unique buildings including mock-Tudor houses, a remarkable heavily disguised five-storey water tower with a 'cottage' on top and, of course, a working windmill. The village was originally constructed during the 1910s and '20s and includes an artificial lake known as the Meare covering three acres. The most iconic and famous edifice, the House in the Clouds, was built in 1923/4. Standing around 75 feet (22.86 metres) high, it is now a privately owned high-rise holiday retreat and is available to let. A games room now occupies the space under the pitched roof where a 50,000-gallon water tank resided until its removal in 1977.

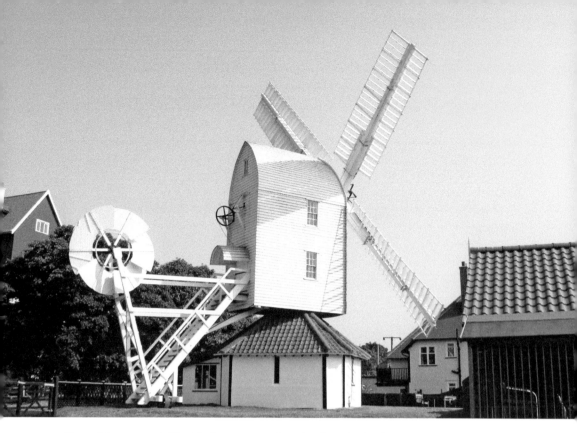

Above: Thorpeness Mill with the House in the Clouds in the background (2016).

Below: A view across Thorpeness Meare (2016).

Unlike the other buildings that, contrary to appearances, were brand new, the windmill had a former life at Aldringham a few miles away. Originally built in 1803 as a traditional post corn mill, when moved to its present location opposite the House in the Clouds it was converted to pump water to its new neighbour via underground piping. It replaced an iron windpump or wind engine installed around 1910, which was not considered sufficiently pleasing to the eye. Depending on the wind conditions, up to 1,800 imperial gallons (8,200 litres) of water could be pumped every hour from a well 28 feet (8.53 metres) beneath the ground. The mill was taken down at Aldringham and rebuilt at Thorpeness during late 1922 and early 1923. Much of the reconstruction work was attributed to the well-known Suffolk millwright Amos Clarke, who died in 1953. The central post was drilled in order to fit a pump rod and other technical modifications were necessary to complete the transformation from corn mill to hollow-post windpump. It was at this time that a new single-storey concrete roundhouse was built, though it was actually a rather unusual square design. The mill was equipped with four patent sails, a cast-iron windshaft and a six-bladed fantail. It continued to pump the village's water supply until around 1940, when the job was taken over by an engine. Mains water finally arrived in 1963. The shutters were removed from the mill's sails after it stopped work but it remained in a reasonable state of repair for some years.

By the early 1970s Thorpeness Windmill was in need of urgent repair and lost its fantail during a storm in 1972. The following year it was in danger of being burned down due to a heath fire but the damage was limited to one sail and stock. Full restoration finally took place in 1976–77 at a cost of around £10,000. This sum was split between the Thorpeness estate, Suffolk County Council and the Countryside Commission. The ownership of the mill was transferred from the Thorpeness estate to the council and it remained their responsibility until 2010. It was then put on the property market at a guide price of £150,000 but eventually went to private buyers for £72,100. The new owners pledged to spend over £100,000 restoring the mill. Thorpeness Windmill was indeed restored and brought back to working order by 2015. Much of the work was carried out by well-respected millwright Vincent Pargetter, who sadly died on 31 October 2015.

Thorpeness is a magnet for tourists during summer months but is much less busy at other times of year. The village is unique and has many charms and eccentricities. The mill itself can be found alongside a track from the main road through the village.

MID-SUFFOLK

Eastbridge Windpump, Stowmarket
Location: Museum of East Anglian Life, Crowe Street, Stowmarket, IP14 1DL. The mill can be viewed externally during museum opening times.

During its working days this smock windpump helped drain marshes at Minsmere Levels near Leiston, along with three others. It took its name from a nearby hamlet and was probably the work of millwright Robert Martin. Eastbridge Windpump is thought

to have been erected around halfway through the nineteenth century and continued to operate until 1939, when it was damaged and subsequently became derelict. Dan England, a millwright from Ludham in Norfolk, had strengthened the structure during the 1920s by attaching part of the framework from another local drainage mill to the external weatherboarding. The same millwright built the windpump that still stands by the river at St Olaves (*see* below).

Eastbridge Windpump finally succumbed to the elements after decades of neglect and crumbled to the ground in early 1977. The decision was taken to rebuild it at the Museum of East Anglian Life in Stowmarket, using as much of the original materials as could be salvaged. The work began in 1978 and lasted for two years. The resurrected mill has an eight-sided smock body and stands around 30 feet (9.14 metres) in height from its low brick base to the top of its cap. The sail diameter is 44 feet (13.41 metres). The mill is equipped with a fantail and a cast-iron windshaft plus a plunger pump. Three decades after its relocation to Stowmarket the structure was again in need of renovation and an appeal was launched in 2013 to help towards the cost. This included repairing and repainting the smock body, cap and sails, plus additional work. The museum also has a working watermill – transported from its original home near Ipswich to save it from oblivion beneath the waters of the new Alton Reservoir – and a steam engine from Deben Mills, Wickham Market (*see* chapters 5 and 6).

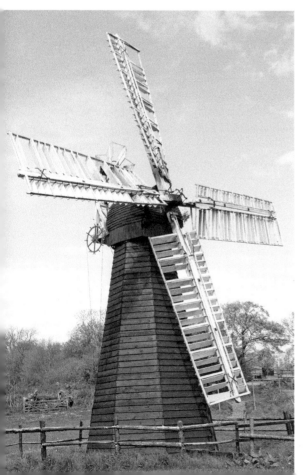

Eastbridge Windpump (2008). (Image supplied by Museum of East Anglian Life, Stowmarket)

OTHER DRAINAGE MILLS/WINDPUMPS

Priory Mill on the River Waveney at St Olaves (NR31) was historically a Suffolk mill throughout its working life before boundary changes in 1974 sent it into Norfolk. Originally constructed in 1910 as an open-trestle or skeleton windpump, it was modified in 1928 with the addition of a weatherboarded body. It last worked in 1957 and was restored during the 1970s, and again following storm damage in January 2007.

Other former Suffolk drainage mills now in Norfolk due to boundary revisions include Belton Black Mill, located on marshes near Great Yarmouth, and two derelict windpumps at Fritton (Caldecott Mill and Fritton Marsh Mill).

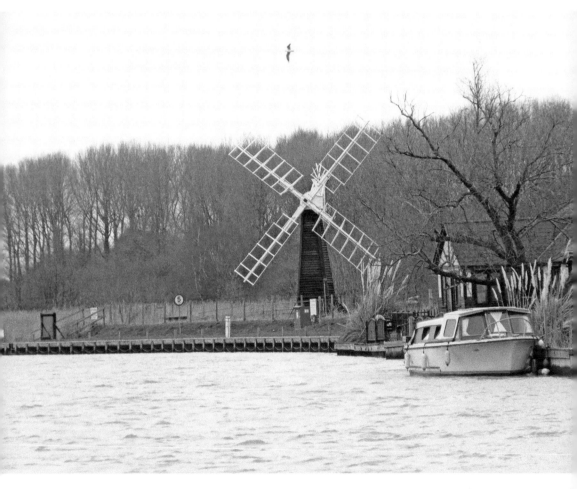

Priory Mill at St Olaves was originally in Suffolk but is now in Norfolk due to boundary realignment (2017).

Chapter 5

Watermills: History and Evolution

EARLY HISTORY

The origins of the waterwheel can be traced back to ancient Greece and Rome. It is now thought that as early as the second century BC, such wheels may have been in use to drive millstones. Waterwheels were used to operate various mechanical devices in China during the first century AD and watermills were recorded in India three centuries later. The Romans took their water-powered technology to other countries under their control. Watermills were commonplace in medieval Europe, some of which were large industrial units far removed from their primitive forerunners.

A watermill was recorded in Dover in the second half of the eighth century but a few may have existed in England during the previous century. The Domesday Book of 1086 recorded 5,624 mills in England, though some consider this figure to be understated as it did not include some northern counties. According to author Douglas Pluck, the survey counted the number of pairs of millstones rather than the number of actual mills, though most would probably have been very modest constructions often using a single pair of small millstones.

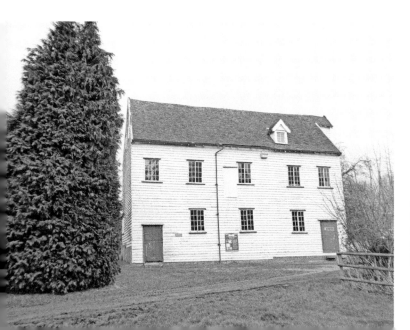

Alton Watermill was rebuilt at the Museum of East Anglian Life, Stowmarket, and is still in working order (2018).

Milling was already well established in Suffolk by this time, long before the county's first windmill turned a sail. Some mill sites date back to Saxon times and the Domesday Book revealed that 178 separate settlements in the county had at least one mill. Although the survey does not differentiate between different types, most would have been powered either by water or horses. Some may have been tiny hand mills or querns. Horse-powered mills were in use for hundreds of years alongside their water and wind-powered brethren but gradually died out.

WATERWHEELS AND TURBINES

Usually constructed beside or close to rivers, watermills used the power of water to drive waterwheels for various purposes. The wheel was connected to an axle that operated other mechanical equipment. Channels or pipes diverted water from the river towards the waterwheel. This was known by a variety of names including mill race, head race, leat and flume. Water left the wheel via a tail race. Some mills took water from a nearby pond or lake. Euston Mill in Suffolk was supplied by a man-made lake.

The earliest mills used a simple gearless waterwheel fitted horizontally on a vertical axle. This was followed by the vertical wheel attached to a horizontal shaft and incorporating a basic gearing system. As wheels grew larger and mill technology advanced the gearing became more sophisticated. Vertically mounted wheels were used in most British watermills. Wheels and axles were traditionally made entirely of wood and this practice continued for centuries. Oak was the wood of choice for wheels and axles but other woods were sometimes used. Cast iron was first used for waterwheels and axles by engineer John Smeaton in the late eighteenth century. Many wheels produced during the Victorian period were of cast iron and were generally larger than their wooden predecessors. Composite wheels made from wood and metal were also used. There were several different designs of waterwheel, the main types being undershot, overshot, pitch-back and breast-shot.

The waterwheel of Woodbridge Tide Mill (2014).

Undershot wheels were driven by the speed of the water supplied to the bottom of the wheel and were quite simple to produce but generally inefficient. General J. V. Poncelet of France introduced his Poncelet wheel in the 1820s, which was a modified and much more efficient version of the undershot wheel. The wheel turned at a faster rate and was often used in corn and paper mills. The overshot wheel took its water from the top of the wheel and was probably the most powerful of all the different types. Buckets on the wheel collected water and the wheel was turned by the weight of the water. The pitch-back wheel was similar to the overshot but, unlike the latter, it turned in the same direction as the water flow. The breast-shot wheel's water came onto the wheel at axle level, though variations included high and low breast-shots. Like the overshot type the breast-shot had buckets fitted to the wheel.

From the nineteenth century onwards, some mill owners removed their waterwheels and fitted water turbines instead. The origins of the water turbine can be traced back to the Romans around the fourth century AD. Major advancements during the nineteenth century led to the development of the modern turbine. It was claimed to be much more efficient than traditional waterwheels, though the high cost restricted its use mainly to the larger and more successful mills.

MILLSTONES AND OTHER MACHINERY

Like windmills, most watermills used millstones to produce flour and other foodstuffs, but water power could also be used to drive other machinery. The number of millstones ranged from a single pair in early small mills to six pairs or more in later large ones. Earsham Mill, just on the Norfolk side of the border with Suffolk, was claimed to have had as many as twelve pairs driven by water and steam power. Stone sizes ranged from around 2.5 to 5 feet (0.76–1.52 metres) in diameter and the largest could weigh around a ton apiece. As with windmill stones the lower bed stone remained static while the upper runner stone revolved at a speed of 100–180 times a minute depending on its size, with smaller stones clocking up many more revolutions than their larger and heavier counterparts. Various types included French burr, Peak and Cullin. Millstones could be driven from above (overdrift) or below (underdrift). Underdrift stones were often supported by a heavy wooden or (later) metal framework known as a Hurst frame.

In addition to milling the watermill could be equipped to saw timber, strip bark from trees (for use in the tanning industry), fulling (the cleaning and finishing of cloth) and to produce paper, textiles and many other products. The large majority of Suffolk's watermills ground grain but some were used for other purposes. Bungay Watermill was converted to produce paper for part of its working life, a process that required the use of great amounts of water. Syleham Watermill, which burned down in 1928, also started life as a conventional flour mill before being adapted to produce a type of coarse cloth called drabbet, from which smocks were made.

The advent of roller milling equipment using steel rollers in lieu of millstones led to the mass production of fine white flour. In the last quarter of the nineteenth century

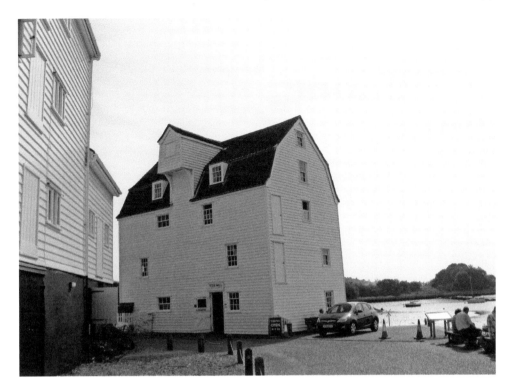

Woodbridge Tide Mill is one of only two currently working in England (2014).

an increasing number of water millers installed roller plants, sometimes supplementing but often replacing the millstones. With much more space available in a typical watermill than in even a large tower windmill, the roller plants grew larger as the technology progressed. Some smaller mills retained their waterwheels but more power was required to drive the larger plants. Some installed water turbines while others used steam or oil engines. Those mills that retained their waterwheel and stones often switched to the production of animal feed (provender milling).

TIDE MILLS

The tide mill differed from other watermills in that it was constructed at the mouth of a river or estuary and used the motive power of the tide. Water was collected in a millpond or reservoir. It is thought that the first tide mills may have been situated on the coast of Ireland as early as the sixth century AD. Only two working tide mills now exist in England, these being at Eling, Hampshire, and Woodbridge in Suffolk. Recently restored to its former glory, Woodbridge Tide Mill is one of the county's best known and most picturesque watermills. Its reservoir once covered a large area and enabled the mill to work for several hours a day. The current pond is just a fraction of its original size but milling demonstrations still take place when tides allow.

RISE AND DECLINE OF THE WATERMILL

Like windmills, watermills grew ever larger and more sophisticated over the centuries. They often worked in close proximity to each other before both went into a steep decline at around the same time. A few windmills were literally built on top of watermills. West Ashling Mill in West Sussex consisted of a small hollow-post windmill on the roof of a watermill. The main building still exists and has become a large private house, but the windmill was dismantled many years ago. Union Mills at Burnham Overy in Norfolk consisted of a six-storey tower windmill attached to a watermill, with both mills being capable of driving the other's machinery. Also in Norfolk, Little Cressingham Combined Mill worked by wind and water power, with a wheel house adjoining the six-storey windmill tower and a separate pumphouse close by. Both of the Norfolk mills are still standing but no longer working.

The earliest watermills were made entirely from wood and even some relatively late examples used this material. Many were timber framed with horizontal weatherboarding. Quite a lot burned down and later mills, particularly larger ones, were often of brick construction. One of the more recognisable exterior features of most watermills was the lucam, which extended from the roof and covered the sack hoist. In some cases this was relatively small but the lucam of Bungay Watermill was (and still is despite being converted to residential use) a very large and prominent feature. Some large mills had more than one lucam.

As watermill sites were often in constant use for hundreds of years, or in some cases over a thousand years, many complete or partial rebuilds would have taken place with the final mill bearing little resemblance to the first. It has been suggested that the larger watermills have a strong claim to being the first true factories and the forerunners of modern mechanised industry. From supplying their local village or small town the larger mills went on to send their flour and other wares far and wide, including overseas markets. Some milling families owned several mills of different types, using a combination of water, wind, steam and diesel power. In Suffolk the Marston and Clover families were particularly well known. Towards the end of their working lives a number of the remaining larger watermills were taken over by major players including Hovis.

As with the windmill, the watermill had reached the zenith of its long technical development when other factors combined to hasten its demise. Once steam and oil engines had been installed to supplement and ultimately replace water power, it was only a matter of time before enormous industrial mills were built well away from the ancient rural sites. The coming of electricity as a viable power source accelerated the decline of traditional watermills and many went out of use during the late nineteenth and early twentieth centuries. Nevertheless, some managed to keep going long after most had become derelict or been converted to other uses. Today a few are still in full working order but some are now private homes, hotels, holiday accommodation or restaurants. A number of the finest Suffolk survivors are featured in the following chapter.

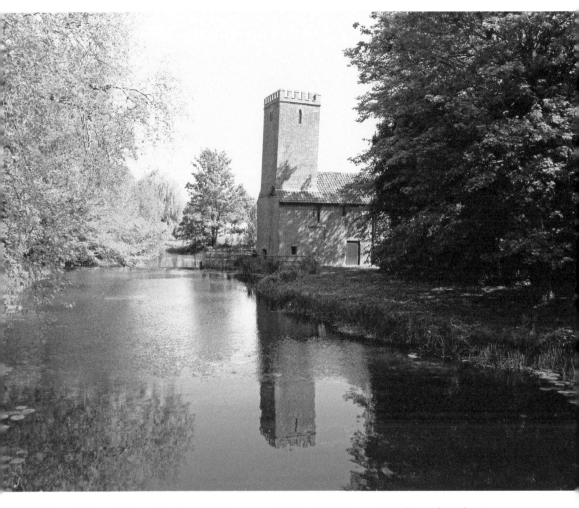

Euston Watermill in spring (2011). (Image supplied by the Duke and Duchess of Grafton)

Chapter 6

Suffolk Watermills

Suffolk can lay claim to arguably the most famous watermill in Britain. Flatford Mill at East Bergholt appears in some of artist John Constable's greatest works and was owned by members of his family. It stopped work long ago but is firmly on the tourist trail along with other reminders of one of Suffolk's favourite sons. Woodbridge Tide Mill, Pakenham Watermill and Alton Watermill at the Museum of East Anglian Life, Stowmarket, are also well known in the county and beyond. All three still operate on a part-time basis and are open to the public. Euston Mill can be visited when Euston Hall and grounds are open. Sudbury Mill has been converted to a hotel and the mills at Kersey and Wickham Market are used as bases for businesses with public access. All of the aforementioned watermills are featured in this chapter, along with others that have been converted to other uses while retaining much of their original character.

NORTH SUFFOLK

Bungay Watermill (River Waveney)

Location: Staithe Road, Bungay, NR35 1EU. Privately owned and converted to residential use.

Watermills were recorded at Bungay in the Domesday Book of 1086. The mill building that still stands at Bungay Staithe largely dates from 1902 and was the last of several rebuilds due to fire.

Henry Wright and Edmund Cooke were recorded at the present site in 1618 and Francis Flowerdaye was the miller there in 1662. The mill and surrounding area was bought by local apothecary John Dalling and his associate Richard Nelson in 1704. It remained in the Dalling family for several decades but by 1770 was the property of a family named Gooch. They appear to have entirely rebuilt the mill in 1771 before selling it to William Kingsbury around three years later. After being sold at auction in 1775 the mill was occupied by Henry Gooch and Thomas Cotton but it is unclear whether at this time they were owners or tenants. They may have initially leased the premises before finally purchasing it in 1778. The new owners suffered a serious setback in January 1779 when the mill was devastated by fire just a few years after being constructed, but it was rebuilt around six months later.

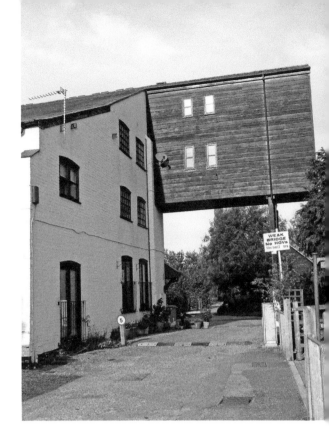

The weatherboarded lucam of Bungay Watermill projects over the road below (2016).

It appears that by this time two watermills existed on the same site, both of which were originally corn mills. William Mann is said to have purchased Bungay Mills in 1784 – indicating that there was more than one – and is thought to have leased one to Joseph Hooper while operating the other himself. Hooper converted his to produce paper while the other – also known as Bardolph or Bardolfes Mill – continued as a corn mill. It was then sold at auction in 1786 and again two years later. In 1788 the mill was described as having two pairs of French burr millstones, whereas it was previously said to have three pairs. On this occasion a smock windmill was included in the package in addition to two houses, granaries and other buildings. Joseph Hooper continued to run the paper mill for many years and passed away in 1817. James Betts later took over the paper mill before being declared bankrupt in June 1829, and it was sold the following year. References to Bungay Mill(s) between this date and 1864 indicate that paper production may have been the only business being carried out onsite, though there is a record of a miller named David Walker in 1850. Several individuals were listed as papermakers over the years and Benjamin Ward was the occupant when fire again tore through the mill in 1864. As the corn and paper mills were said to be adjoining it is assumed that little or nothing was left of either.

By 1870 the derelict site had become the property of Charles Marston, who also had a watermill at Earsham and a steam mill at Harleston, both just over the border in Norfolk. From the ashes he built a new corn watermill and there is no further evidence of paper manufacturing at the Staithe. At some point between 1884 and 1892, Charles

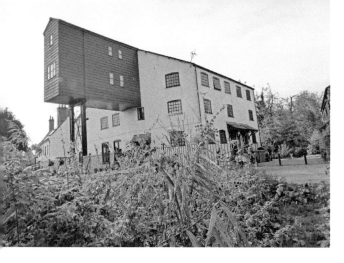

Bungay Watermill has been converted to residential use (2016).

Marston added a steam engine and roller mill but milling by water power continued. In 1890 he placed an advertisement seeking to purchase a new or second-hand waterwheel. Unfortunately yet another serious fire broke out on 25 February 1902, but once again the building was rebuilt and milling resumed.

Despite losing a leg to gangrene, Charles Marston remained in charge at the mill until his death in 1919, by which time he was in his late seventies. His son, Charles Candace Marston, was born at Mill House in Bungay and inherited his father's businesses including the mills at Bungay, Earsham and Harleston. Bungay Mill later switched over to producing animal feed and during the 1940s was taken over by Hovis Ltd. Though now a subsidiary of the parent company, the business continued to be known as Charles Marston (Bungay) Ltd. It was still a working mill when purchased around 1955 by a gentleman called Mr Green, but within a year or two the waterwheel and other machinery had been taken out. It was then used for a variety of purposes before finally being converted to residential use.

The three-storey brick building as it appears today is still very recognisable as a former watermill despite its conversion. As can be seen from the photographs, it still retains its prominent weatherboarded lucam (covered sack hoist), which projects over the narrow road below. Still known as The Watermill – or sometimes locally as Marston's Mill – it stands close to The Maltings, which has also been converted to residential use. Although part of the mill stream has been filled in, the riverside location is largely unspoiled. The Staithe is only a five-minute walk from the town centre and public pathways beside the river cater for those who fancy a longer hike.

Bungay Watermill is situated on the River Waveney between the mills at Earsham and Ellingham, both of which are officially in Norfolk. Earsham Mill is now a derelict shell while Ellingham Mill has been converted to residential and business use. In addition to these, another watermill known as Wainford Mill once existed in Pirnhow Street, Ditchingham (NR35 2RU) on the outskirts of Bungay. It straddled the boundary between Norfolk and Suffolk but was demolished in the 1890s. The Mill House and Wainford Maltings – completely rebuilt for residential use – still survive. The town was also once home to eight windmills and the converted remains of Flixton Road Tower Mill can still be seen (*see* chapter 3).

MID-SUFFOLK

Alton Watermill (River Rat), Stowmarket

Location: Museum of East Anglian Life, Crowe Street, Stowmarket, IP14 1DL. The mill can be viewed and entered during museum opening times. It is in working order and is operated 'on a regular basis'.

Alton Watermill was originally situated to the south of Ipswich between the villages of Stutton and Holbrook. A miller and corn merchant named Robert Southgate ran the mill from 1879 until 1903. He died in 1922 but George Blackmore took over as miller between 1903 and the start of the Second World War, when the mill stopped working commercially. Gerald Blackmore assisted his father during the 1930s.

Over thirty years later the mill found itself in the path of the proposed Alton Water reservoir. Along with its mill house and cart lodge it managed to escape an ignominious underwater fate when it was decided that they should be spared. The buildings were carefully taken down and moved to the Museum of East Anglian Life at Stowmarket in 1973, where they were rebuilt in the same configuration as at their original location. The Alton Reservoir was finally completed in 1987 and is Suffolk's largest artificial reservoir. Much of the Tattingstone Valley, previously used mainly as farmland, is now submerged.

Alton Mill has become a major attraction at its new home and is in full working order. It now takes its water from the River Rat by means of a pump. The mill and cart lodge were originally constructed around 1800. The mill house was built in 1765 and enlarged during the nineteenth century.

Among many other interesting exhibits the museum also has a mid-nineteenth-century smock drainage mill known as Eastbridge Windpump (*see* chapter 4) and a steam engine from Deben Mills at Wickham Market.

Alton Watermill and Mill House, Museum of East Anglian Life, Stowmarket (2018).

 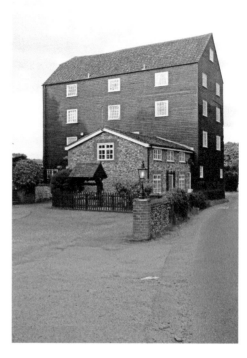

Hawks Mill (*left*) and Bosmere Mill (*right*), Needham Market (2008). (Images supplied by Bob Jones)

Hawks and Bosmere Watermills (River Gipping), Needham Market

Locations: Hawks Mill, Hawks Mill Street, Needham Market, IP6 8LU; Bosmere Mill, Coddenham Road, Needham Market, IP6 8NU. Both have been converted to residential use.

Though both of these former watermills now function as living accommodation, they still retain much of their character and charm. Hawks Mill in particular is in a picturesque location on the River Gipping above a late eighteenth-century bridge. The present mill was constructed in 1884 and a date stone is incorporated into the front of the four-storey red-brick building. It was extended in 1892 with the addition of two wings each two storeys tall plus attics. It has a pantiled roof and a white-painted weatherboarded lucam. In its working days Hawks Mill was a traditional corn mill but used an Armfield water turbine in lieu of a waterwheel. This was said to still be in place and capable of operating in the early 1980s, though the milling machinery had already been taken out. The mill has now been divided into nine separate apartments.

Bosmere Mill was built in the late eighteenth or early nineteenth century and is four storeys tall plus an attic. In contrast to Hawks Mill it is timber framed and the weatherboarding is painted black. During the late nineteenth or early twentieth century a two-storey house was built adjoining the mill. This is mainly of flint construction with some brickwork. After the mill ceased work its milling machinery was removed and the iron breast-shot waterwheel was moved from its wheelhouse to a new external

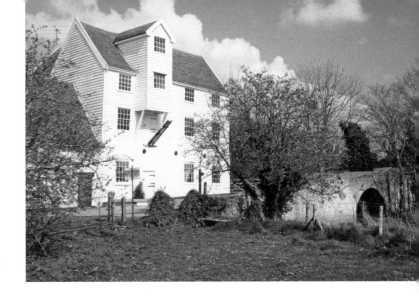

Baylham Watermill (2008). (Image supplied by Bob Jones)

position. The Grade II-listed building was once used as a restaurant but has now been converted into flats.

Baylham Watermill (River Gipping)

Location: Mill Lane, Baylham, IP6 8LG. Privately owned and not open to the public.

Baylham Mill, located a few miles south-east of Needham Market, last worked during the 1970s but appears to have retained all of its machinery. This includes a cast-iron breast-shot waterwheel, five pairs of millstones and much besides. All five pairs of stones could be driven by water power and two pairs could also be operated by an oil engine manufactured by the Ipswich firm E. R. & F. Turner.

Baylham Mill is situated in a pleasant rural location beside the River Gipping. It was built in the nineteenth century and is three storeys tall plus attics. The upper part of the mill is timber framed and weatherboarded above a single-storey brick base. The exterior is painted white and the lucam is a prominent feature extending over two floors. The oldest part of the adjoining two-storey Mill House has been dated to the early sixteenth century, with nineteenth-century additions.

EAST SUFFOLK

Deben Mills (River Deben), Wickham Market

Location: Deben Mills, Lower Hacheston, Wickham Market, IP13 0RG. Privately owned and used as the base of a family business. Open to customers during trading hours.

Deben Mills in Wickham Market is one of Suffolk's most photogenic mill locations and consists of an eighteenth-century watermill alongside a mill house and a nineteenth-century steam mill. The watermill, which still contains its milling machinery, is mainly of brick construction but is timber framed and partly weatherboarded. It is two storeys high plus an attic and much of the building is painted white. Three pairs

Left: Deben Mills, Wickham Market (2018). *Right*: Woodbridge Tide Mill is one of Suffolk's best-known watermills (2014).

of overdrift millstones were driven by a cast-iron breast-shot waterwheel 18.5 feet (5.64 metres) in diameter and 6 feet (1.83 metres) wide. A three-storey mill house adjoins the watermill. The nearby brick steam mill was built in 1868 and has three floors and a weatherboarded lucam. The building has lost its machinery and chimney and is now used as a shop and for storage.

The site's long association with the Rackham family began in 1885 when Reuben Rackham took it over. In 1893 he installed a large horizontal condensing steam engine made by local firm Whitmore and Binyon, which was in use until 1957. It was later gifted to the Museum of East Anglian Life at Stowmarket, where it can still be seen working on demonstration days.

Deben Mills stopped producing flour in 1970 but the premises continues to be used as the base of a family business, which supplies animal and pet food and solid fuel.

Woodbridge Tide Mill (River Deben)

Location: Tide Mill Living Museum, Tide Mill Way, Woodbridge, IP12 1BY. In working order and open to the public daily between Easter and September and some other dates. Milling is dependent on tides. Exterior can be viewed at any time.

Woodbridge Tide Mill is one of East Anglia's best-known watermills and one of only a few still in full working order. Its location is very photogenic and has been featured in numerous publications over the course of many years, no doubt helping to lure a large number of tourists to this south-eastern corner of Suffolk. As its name implies, a tide mill utilises water deposited by the tide in an adjacent pond. Wylie's Pond at Woodbridge covered 7 acres (28,000 square metres) during the mill's commercial heyday, which allowed four hours of milling every day. Most of the original pond now serves as a marina for boats and is very popular. Milling still takes place for the entertainment and education of visitors but the millpond now only occupies around half an acre.

It is known that a tide mill existed on this site in the twelfth century and there have been several different buildings here over the centuries. King Henry VIII took the mill from Woodbridge Priory in 1536 during the Dissolution, ending around 350 years of ownership by the Augustinian order. Following his death it was passed to his daughter Elizabeth I, who sold the mill and disused priory to Thomas Seckford. After remaining in the same family for over a century, the mill later changed hands a number of times. The present mill dates from 1793 and worked until 1957, by which time it was the last commercially operational tide mill in England.

In 1968 work began to restore the mill and it opened as a tourist attraction in 1973. Now operated by the Woodbridge Tide Mill Trust as a Living Museum, much additional restoration work was necessary in 2011 and it was temporarily closed to the public before reopening the following year. A new waterwheel was installed and the machinery was refurbished. The weatherboarding was given a fresh coat of paint and it once again produces wholemeal flour. It is now said to be one of just two working tide mills in the country, the other being at Eling, Southampton. Visitors to the market town of Woodbridge may also be interested in Buttrum's Tower Windmill, which stands in Burkitt Road (*see* chapter 3).

SOUTH SUFFOLK

Kersey Watermill (River Brett)

Location: Bildeston Road, Kersey, near Hadleigh, IP7 6DP. The mill is now used as a base for several businesses and currently undergoing restoration, and is open to the public.

Kersey Mill dates from the eighteenth and nineteenth centuries but the Domesday Book of 1086 records a much earlier predecessor on this site. The present mill is four stories tall and is timber framed with horizontal weatherboarding. In the late nineteenth century an engine was installed, which drove three pairs of stones. The waterwheel last worked around seventy years ago and much of the machinery has been removed. After thieves took lead from the roof during the 1960s, rainwater caused much internal damage. The derelict mill was sold and partially restored during the 1970s. In the early twenty-first century it was used for weddings and other functions but this business later went into liquidation.

Kersey Watermill (2016). (Image supplied by Steve de Lara-Bell)

In 2012 the property, including a former maltings, a mill house and 17 acres of land, was purchased by Steve and Alison de Lara-Bell. It is currently in use as a base for a number of businesses and is again available to book for weddings and other events. The watermill is now being restored and the present owners' eventual aim is to return it to full working order.

East Bergholt: Flatford Watermill (River Stour)

Location: Flatford Road, East Bergholt, CO7 6UL. Owned by the National Trust and leased to the Field Studies Council. No public access to the mill interior but the exterior can be viewed at any time. Parking is available on site (charges apply).

Flatford Mill is one of the most famous of all watermills due mainly to its strong association with the Constable family. It is featured in several of the best-known paintings by John Constable (1776–1837) and attracts thousands of tourists to this previously quiet part of rural Suffolk.

The Domesday Book records a watermill at Flatford in 1086 but its origins go back to Saxon times. In the twelfth century it was owned by the Earl of Norfolk, Roger Bigod. For hundreds of years there was a fulling mill here, in which cloth made from sheep's wool was treated and cleaned. In the early eighteenth century it became a corn mill and so began its connection with the Constable family.

Abram Constable purchased Flatford Mill in 1742 and rebuilt it in 1753. At this time two wooden waterwheels, each with a diameter of 12 feet (3.66 metres), drove two pairs of millstones. In 1768 the mill was inherited by Golding Constable, father of John Constable. John's brother Abram Jr inherited the mill in 1816 following their father's death and sold it thirty years later to William Bentall and Stephen Lott. They replaced the twin waterwheels with one large iron wheel measuring 16 feet (4.88 metres) in diameter and 14 feet (4.27 metres) in width. A new wheel house was constructed and a number of other changes were made. After the departure of his co-owner in 1849, William Bentall added a steam mill but continued milling by water power. He sold both mills in 1864. Several new owners came and went between this date and 1901, when the watermill was converted to residential use. This was not, however, the end of its working life, as a gentleman called Viscount Buckmaster restored the mill and brought it back into use in 1904.

When builder Thomas Parkington purchased the watermill and Willy Lott's House in 1926, both were in a very sorry state. He repaired both properties but was responsible for removing the mill's machinery and waterwheel. The mill was converted to an arts/leisure centre. Following his death in 1943, both Willy Lott's House – immortalised by John Constable in his painting *The Hay Wain* – and Flatford Mill were bequeathed to the National Trust. Three years later the Field Studies Council began leasing the properties. Visitors to Constable Country, as it has long been known, can view the exterior of the mill and Willy Lott's House plus the famous millpond at close quarters. Flatford Lock is situated nearby and this also features in some of the great artist's works.

Above: Flatford Mill and Mill House. *Below*: Willy Lott's House, site of *The Hay Wain* by John Constable (1999). (Images reproduced by kind permission of National Trust, Flatford)

Flatford Lock (1999).
(National Trust, Flatford)

Sudbury Watermill (River Stour)

Location: Walnut Tree Lane, Sudbury, CO10 1BD. Converted into a hotel.

This well-known former mill in south-west Suffolk, close to its border with Essex, is now used as a hotel and restaurant. It occupies one of Suffolk's oldest watermill sites, possibly going back to Saxon times. Part of the present building may date from 1692, though most of it was built during the eighteenth and nineteenth centuries with later additions. It is four storeys tall plus attics and is partly weatherboarded, though later extensions are of brick construction.

From around the middle of the nineteenth century until it ceased work in 1964, the mill was owned by the Clover family. They operated a large number of watermills and windmills in Suffolk, several of which are mentioned elsewhere in this book. A roller milling plant powered by a steam engine was installed in the new brick section of the mill by Isaac Clover but the iron waterwheel, made by Whitmore and Binyon in 1863, remained in position in the older part of the building. It still exists today and now works by electricity. The millpond and mill race can also still be seen.

Sudbury Watermill has been converted to a hotel (2008). (Image supplied by Bob Jones)

WEST SUFFOLK

Euston Watermill

Location: Euston Hall, Euston, IP24 2QP. Watermill in the grounds of Euston Hall. Open to the public on some dates between May and September only.

One of Suffolk's more unusual watermills can be found in the grounds of a stately home a few miles south-east of Thetford. Euston Watermill was originally erected for Lord Arlington by Sir Samuel Morland during the 1670s. It was rebuilt in 1731 by William Kent and given a distinctive church-like appearance. Charles Burrell of Thetford, a leading engineering firm, fitted an iron waterwheel in 1859.

Euston Watermill had a dual role grinding grain and pumping water to the hall and estate including its fountains. An artificial lake was dug beside the mill to supply its water. The mill and its waterwheel underwent full restoration in 2000/1. The work was carried out by the 11th Duke of Grafton and English Heritage.

The grounds of Euston Hall were partly landscaped by the famous Lancelot 'Capability' Brown, who was employed there on an intermittent basis from the late 1760s till the early 1780s. Waterways designed by him were fully restored in 2013. The hall, which was constructed between 1670 and 1676 and substantially redesigned in 1750, is now the family home of the 12th Duke and Duchess of Grafton.

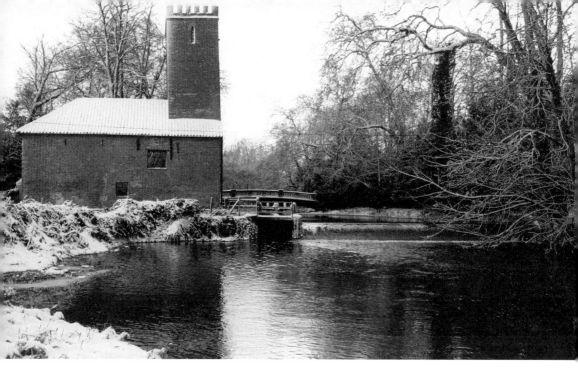

Euston Watermill in winter (2010). (Image supplied by the Duke and Duchess of Grafton)

Pakenham Watermill (River Little Ouse, trib. River Blackbourne)
Location: Mill Road, Pakenham, near Bury St Edmunds, IP31 2NB. In working order and open to the public on some days each week between spring and autumn.

Pakenham Watermill is one of only a few of its kind still in full working order and producing flour. The present building was constructed in the second half of the eighteenth century with early nineteenth-century additions and probably replaced a mill dating from the Tudor period, though milling here predates the Norman Conquest of 1066. For hundreds of years until the Dissolution of the Monasteries the watermill was one of the assets of Bury St Edmunds' Abbey.

Robert Spring became owner of the watermill in 1545 and it stayed in his family for two centuries. It then became the property of the Leheup family, who built the current mill. A stone in the end wall carrying the date '1814' and the initials 'C L' refers to Charles Lowe. He leased the mill, and in that year had a new wooden breast-shot waterwheel and other machinery fitted at quite considerable personal expense. A cast-iron waterwheel measuring 16 feet (4.88 metres) in diameter and 8.5 feet (2.59 metres) in width eventually replaced the wooden one in 1902. Between 1930 and 1974 the mill was worked by Bryan Marriage, who purchased a Blackstone oil engine and a Tattersall roller mill. He wanted to convert the building to residential use following his retirement but the request was turned down.

The mill was acquired in 1978 by the Suffolk Preservation Society and restored to full working order before being opened to the public. Visitors are still able to watch the waterwheel in action on demonstration days. It drives two pairs of millstones to produce wholemeal flour. White flour is produced using the roller mill and oil engine.

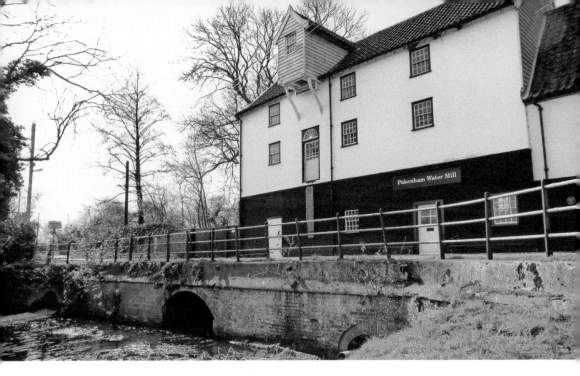

Pakenham Watermill is still in working order (2017).

The front of the mill is adjacent to the roadside. The village of Pakenham is rightly proud of having both a working watermill and tower windmill (*see* chapter 3).

OTHER WATERMILLS

In addition to those featured above, several other watermills still exist in Suffolk but have mainly been converted to private residential use or have become hotels or holiday accommodation. Few are open to the general public and some are hidden away in large private grounds and cannot be seen from the roadside. Some of the more interesting examples are described below.

Mendham Mill on the River Waveney was one of Suffolk's largest watermills and worked until 1938. It was later converted to residential use and is now available for holiday lets. It is situated on a private 8-acre estate (IP20 0NN).

Hoxne Mill (River Waveney) was built in 1846 and replaced an earlier one dating from 1749. Much of the machinery including the waterwheel is reportedly still in place but the privately owned three-storey building is out of bounds to the public. It is located in Watermill Lane, Hoxne, IP21 5AY.

Sproughton Mill on the River Gipping stands on the site of previous mills and was built in its present form in the early nineteenth century. The four-storey brick structure has connections with the Constable family but has lost its iron waterwheel and machinery. Located on Lower Street, Sproughton, IP8 3AA, the mill is privately owned and is not open to the public.

Left: Old watermill on the River Lark at Mildenhall (2006). *Right*: Barton Mills Lock (2007). (Images supplied by Bob Jones)

Ixworth Mill near Bury St Edmunds (IP31 2JN) worked from around 1800 to 1946. It was equipped with a cast-iron breast-shot waterwheel and three pairs of underdrift stones. The mill was featured in an episode of *Dad's Army* and in the film *The Witchfinder General* (1968). It is in a secluded location in private grounds and for several years has been used as family and holiday accommodation. It was advertised for sale in 2017.

Lark Mill sits on the River Lark at Mill Street, Mildenhall, IP28 7DP. A mill existed here before 1066 but the present one dates from the late nineteenth century. Water turbines replaced the waterwheel and a steam engine and roller mill were later installed. Flour was produced until 1969, when it became a provender mill. The building was converted into flats in the early twenty-first century.

Barton Mills Watermill (River Lark) near Mildenhall stood on another ancient milling site in Old Mill Lane, Barton Mills, IP28 6AS. In 1894 its new owners, Parker Brothers, installed a roller mill powered by a steam engine. The mill stopped work during the Second World War and was later demolished, but the mill house and lock still exist.

Bibliography

BOOKS

Ashley, Peter, *Up in the Wind* (Swindon: English Heritage, 2004)
Brown, R. J., *Windmills of England* (London: Robert Hale & Co., 1976)
Flint, Brian, *Suffolk Windmills* (Woodbridge: The Boydell Press Ltd, 1979)
Flint, Brian, *Windmills of East Anglia* (Ipswich: F. W. Pawsey & Sons, 1971)
Herring, Chris, *Spirit of Suffolk Windmills* (Wellington: PiXZ Books/Halsgrove, 2011)
Ling, John, *Windmills of Norfolk* (Stroud: Amberley Publishing, 2015)
Malster, Robert, *The Broads* (Chichester: Phillimore & Co. Ltd, 1993)
Miller, Philippa R., *In Search of Water Mills* (Miller, 1969)
O'Brien, Pat, *Watermills of East Anglia* (Stroud: Tempus Publishing Ltd, 2001)
Pluck, Douglas F., *The River Waveney, Its Watermills and Navigation* (Bungay: Morrow & Co., 1994)
Wailes, Rex, *A Source Book of Windmills and Watermills* (Ward Lock, 1979)
Wailes, Rex, *Suffolk Watermills* (Newcomen Society, 1965)

MILLS WEBSITES

Norfolk Mills:	www.norfolkmills.co.uk
The Mills Archive:	www.millsarchivetrust.org
S.P.A.B. Mills Section:	www.spab.org.uk/mills
Suffolk Mills Group:	www.suffolkmills.org.uk
Windmill World:	www.windmillworld.com
UK Mills:	www.ukmills.co.uk
Windmills.org.uk:	windmills.org.uk
The International Molinological Society:	www.molinology.org

Acknowledgements

The author wishes to thank those who kindly supplied photographs for use in the book: the 12th Duke and Duchess of Grafton (Euston Hall); Dominic and Linda Grixti (Stanton Windmill); Bob Jones; Steve de Lara-Bell (Kersey Watermill); Museum of East Anglian Life, Stowmarket; and Jonathan Neville (Norfolk Mills website).

Thanks also to the following individuals and organisations for their kind assistance: John and Rosalind Middleton and family; Mark Barnard at Suffolk County Council; David Blackburn; Adam Burrows at Natural England; Adrian Colman; English Heritage; National Trust; and The Tide Mill Living Museum, Woodbridge.

Special thanks to John Middleton for acting as driver-navigator on several journeys to take photographs for this book.